Bears

of North America

Written and Photographed by

STAN TEKIELA

an imprint of AdventureKEEN

Cover and interior photos by Stan Tekiela except pg. 5 by **Basel101658/Shutterstock.com** and pg. 3 by **vavavka/Shutterstock.com**. Some photos were taken under controlled conditions.

Edited by Sandy Livoti and Brett Ortler

Proofread by Emily Beaumont

Cover and book design by Jonathan Norberg

Cataloging-in-Publication data is available from the Library of Congress

10 9 8 7 6 5 4 3 2 1
Bears of North America
First Edition 2013 (entitled *Bears: Black, Brown & Polar Bears*)
Second Edition 2023
Copyright © 2013 and 2023 by Stan Tekiela
Published by Adventure Publications
An imprint of AdventureKEEN
310 Garfield Street South
Cambridge, Minnesota 55008
(800) 678-7006
www.adventurepublications.net
All rights reserved
Printed in China
ISBN 978-1-64755-413-2 (pbk.); 978-1-64755-414-9 (ebook)

Dedication

This book is dedicated to all those who feel a special bond with bears in their souls. I hope you feel the same deep connection with bears and appreciate them as I do. After all, bears rule!

Acknowledgments

The following people and organizations have been instrumental in obtaining many of the amazing images in this book. Thank you for all that you do.

Peggy Callahan, Wildlife Science Center (Forest Lake, MN) • Eric and Allison David • Susan and Curt Fagnant • Scott Fitchett • Tom and Jane Gerber • Charles Glatzer • Lee Greenly, Minnesota Wildlife Connection (Sandstone) • Agnieszka Bacal Haralson • James and Shelia Isaak, Alaska Homestead Lodge (Soldotna, AK) • Nathan Lovas • Andy MacPherson • Mammal Collection, Bell Museum of Natural History, University of Minnesota (St. Paul) • Mike and Jeanne Reimer, Churchill Wild (Kleefeld, Manitoba, Canada) • Tara Ryan • Vince Shute Wildlife Sanctuary, the American Bear Association (Orr, MN) • Fortheloveofbears.org

Special thanks to Peggy Callahan, wildlife biologist and extraordinary friend, for reviewing this book. I am continually impressed and amazed at your in-depth knowledge of wildlife. Thanks for everything you do to promote conservation and environmental education.

Thanks!

Contents

Bears—
a lifelong affair

Who doesn't love bears? They're big, furry, and adorable! In childhood, some of our most beloved toys are teddy bears. Later, we grow to love bears as wild animals. I think our affection for bears is, in part, due to their huggable good looks. Their small, narrowly set dark eyes make them appear smart and gentle. Their softly rounded ears add an alert and friendly aspect. But it's how bears move—the way they slowly walk, sometimes standing up on their hind legs, or how they roll playfully on the ground—that makes them even more appealing to us. I have studied and photographed bears throughout my career of more than 35 years. During this time I have found them to be some of the most wonderful, yet dangerous, animals in the world. I am thrilled to bring you a book that includes a wealth of concise and accurate information, along with hard-won images illustrating the behaviors of bears.

You'll discover that—just as in the wild—within these pages, bears rule!

Stan Tekiela

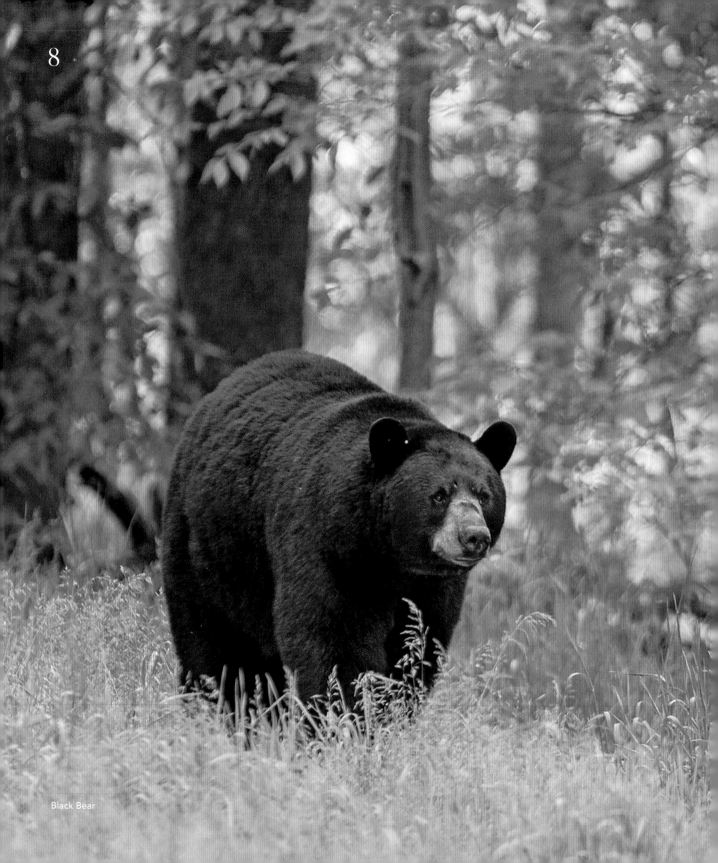

Black Bear

An eminent history

Among native hunting and fishing tribes in North America, there is a long history of respect and reverence for bears. Most large and powerful animals, such as bears, mountain lions, and eagles, influenced Indigenous peoples both personally and spiritually. The Black Bear, for example, was considered a friend of the Cherokee and served as a guide to the spirit world. Bears also provided an important source of items for the tribe. After a bear was killed, the Cherokee would collect the claws and teeth and wear them to impart the bear's power into their own bodies. Similarly, bear fur was worn not only for warmth, but also for protection and as a sign of authority or achievement.

Across Europe, the same history of esteem for bears has been recorded in every civilization. Regarded as the spirits of the forefathers or even as reincarnations of family members, bears remain a strong spiritual guide in some cultures. Today the bear is the state animal for Montana, California, and New Mexico, and it's the national animal for Russia, Finland, Greenland, and Taiwan, China.

The bear family

All of our current-day bears are in the Ursidae family. Ursidae has eight bear species, with numerous subspecies—exactly how many in each is still up for debate. For example, there are at least 16 subspecies of the Black Bear.

The eight species are the Black Bear, Brown Bear, Polar Bear, Asiatic Black Bear, Giant Panda Bear, Sloth Bear, Sun Bear, and Andean Bear. For the purposes of this book, only the three species found in North America will be examined. These are the Black Bear, Brown Bear, and Polar Bear.

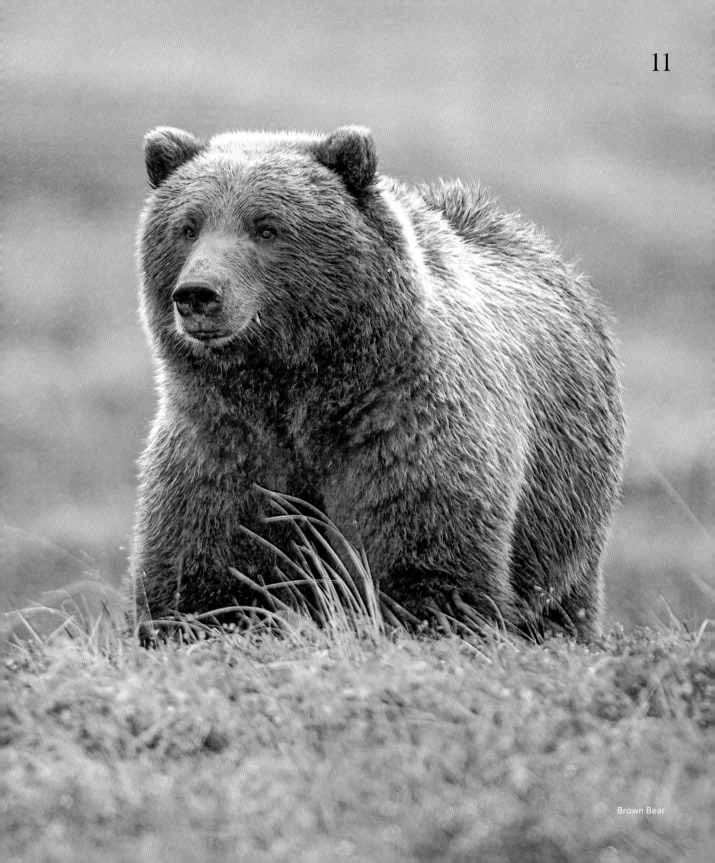

Brown Bear

Origins of the species

Our current-day bears descended from a group of small tree-climbing carnivorous animals. The earliest bears, from about 40 million years ago, were the size of small dogs. Panda Bears were the first to diverge, originating in central Asia about 20 million years ago.

The first bears appeared in what is now known as North America approximately 5 million years ago. A group known as true Bears, the ancestors of today's bears, developed around 3.5 million years ago. Black Bears, as we know them today, became a distinct species about 2.5 million years ago. Brown Bears, Polar Bears, and others came later, beginning around 1 million to 600,000 years ago. Relatively speaking, bear species are not very old, as many modern bird species go back much farther in time. Nonetheless, bear species have done well over the millennia.

Species around the world

Bears are some of the most widely distributed land animals on Earth. Although historically there were many hundreds of bear species around the world, the eight species in existence today are found in 65 countries in North America, South America, Europe, and Asia.

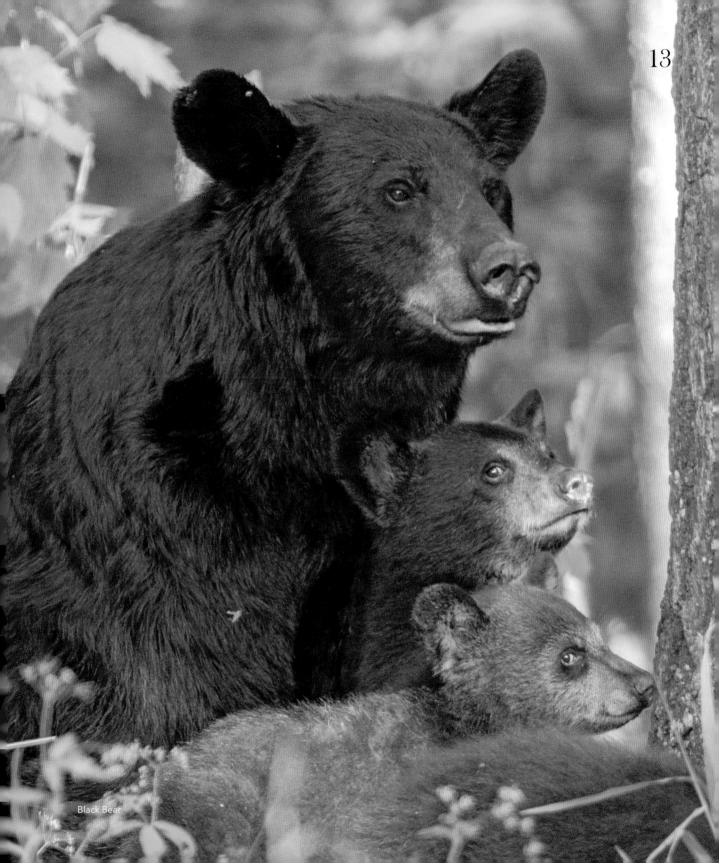

Black Bear

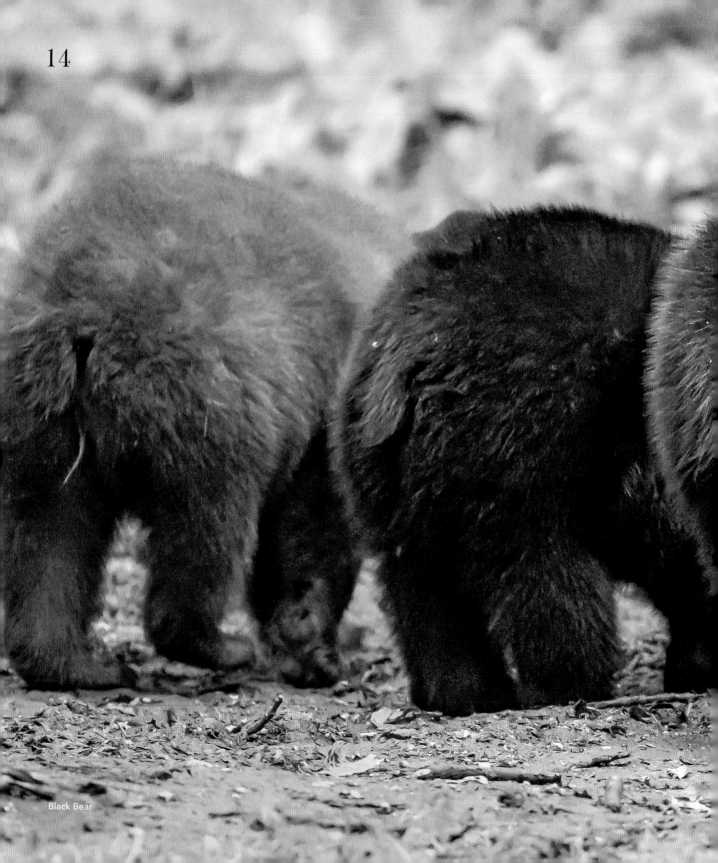

Black Bear

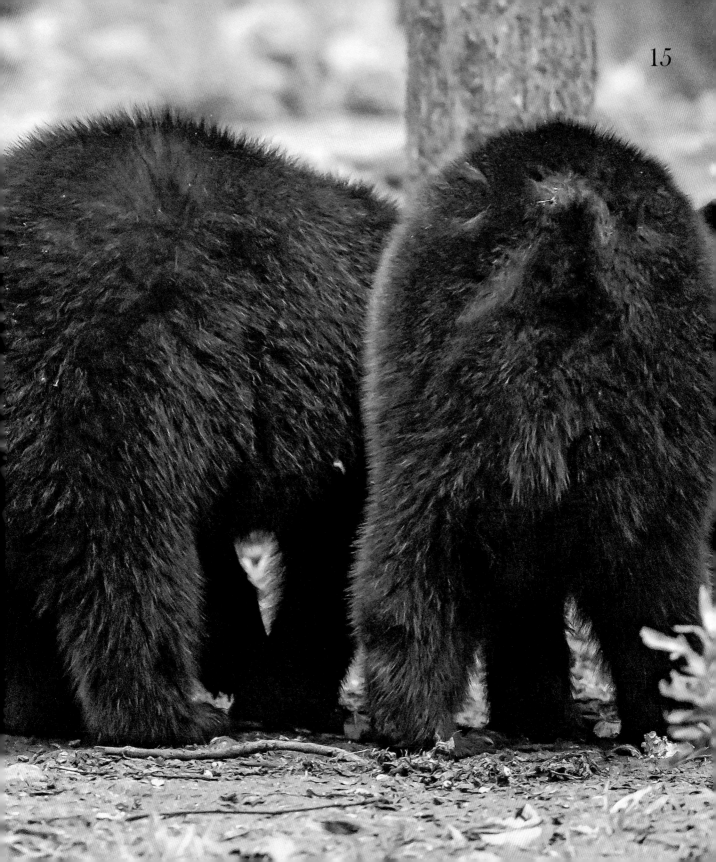

Black Bears

The Black Bear is a small- to medium-size bear. Of the three bear species in the Western Hemisphere, this one is the smallest. Black Bears are true omnivores and live mainly in forested regions. Also known as the American Black Bear, its scientific name, *Ursus americanus*, indicates that it is a bear of the Americas. It occurs in Alaska, Canada, and throughout northern and western states in the Lower 48. Pockets reach down to Florida, Texas, and Mexico.

There are perhaps up to 20 subspecies of Black Bear, including the all-white Spirit Bear or Ghost Bear. This unusual subspecies resides on islands off the western coast of Canada. First Nations people who inhabited the region over the ages were the first to name it. Another name, Kermode Bear, was given in honor of Frances Kermode, a naturalist and curator of the British Columbia Provincial Museum who studied these animals in the early 1900s.

Black Bear

Brown Bear

Brown Bears

The Brown Bear, *Ursus arctos*, is a large and widespread species found in many parts of North America, Europe, Russia, Asia, and Japan. In North America, this bear ranges from Alaska and Canada's Northwest Territories down to the Rocky Mountains in Montana and Wyoming. Its species name, *arctos*, comes from the Greek *arktos* and means "bear."

There are many subspecies of Brown Bear, often leading to much confusion. The Grizzly Bear is a subspecies of Brown Bear that lives in the Rocky Mountains, ranging to other interior parts of the United States and also Canada. Its scientific name, *Ursus arctos horribilis*, translates to "horrible bear" after its perceived bad attitude, which simply describes bears being defensive of young or a food source.

The Kodiak Bear is a Brown Bear subspecies that lives on Kodiak Island in Alaska. This bear is the largest of the Brown Bears, with males weighing 1,500–1,700 pounds.

Along the coast of Alaska and British Columbia, Brown Bears are often called Coastal Brown Bears. Due to their highly nutritious fish diet, they are larger than the inland Brown Bears but not as large as the Kodiaks.

Polar Bears

The largest of the bears, the Polar Bear, lives in some of the coldest parts of the world. Polar Bears are big partly because of their need to keep warm in ice-cold weather. The greater the body mass, the easier it is to retain heat and stay warm; the smaller the body mass, the easier it is to lose heat and stay cool. Thus, the farther north the latitude and the colder the climate, the larger the body mass will be. This association of size and latitude holds true for many animal and bird species, not just bears.

Polar Bear

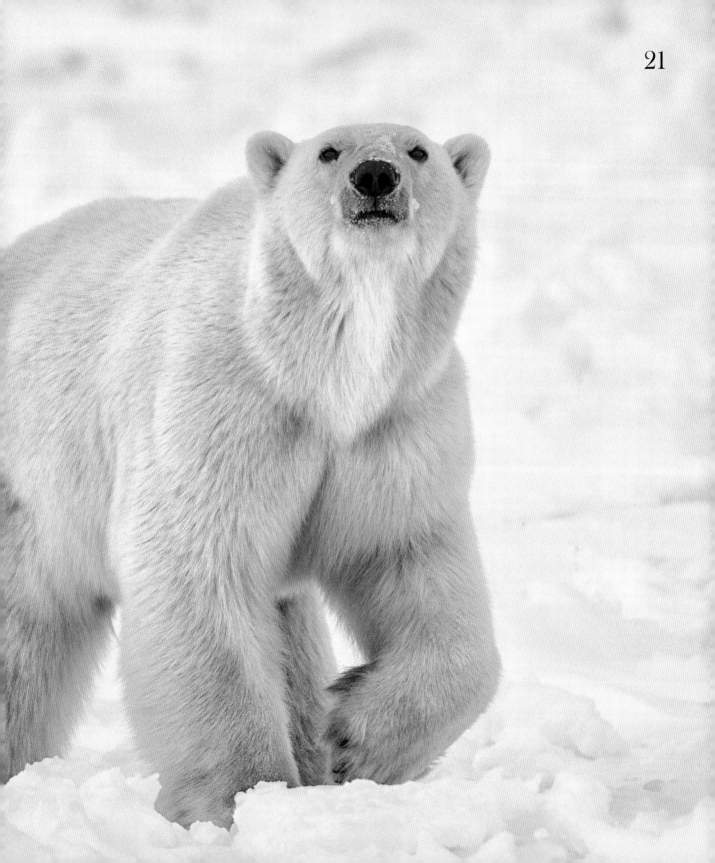

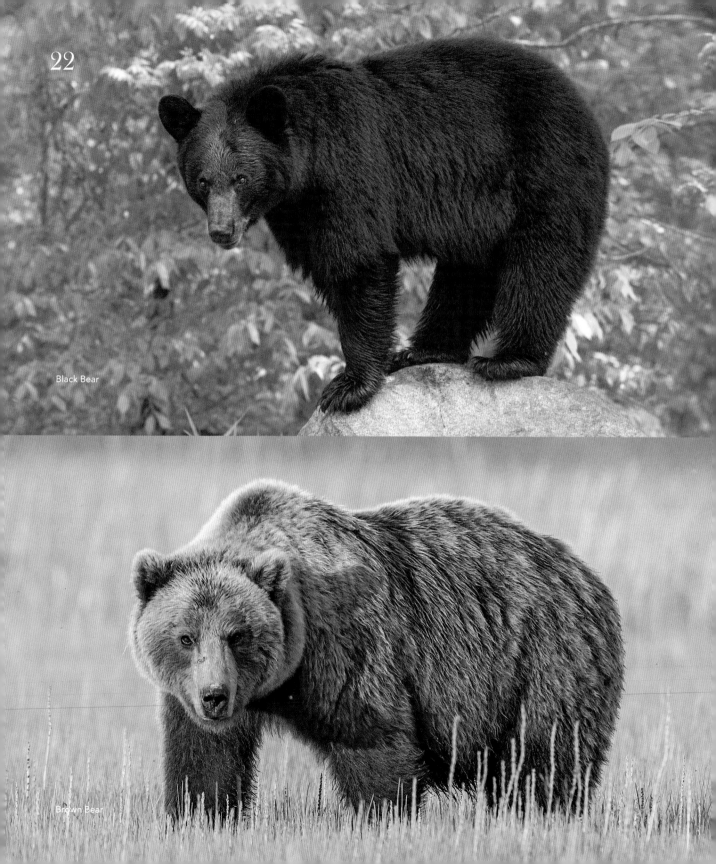

22

Black Bear

Brown Bear

Is it a Black Bear or a Brown Bear?

Distinguishing a Black Bear from a Brown Bear can be a bit tricky. Color isn't an identifying attribute because both species share a variety of fur colors. Size isn't reliable either because most people greatly misjudge it.

Other characteristics are always different. Black Bear ears are often more oval in shape than the shorter, more rounded ears of Brown Bears. Snouts of Black Bears are generally longer and pointed, while Brown Bears have shorter, wider snouts. Black Bears show a straight profile from the eyes to the snout. Brown Bears have a concave profile, called a dished face, and more space between their ears. They also have noticeably longer claws than those of Black Bears.

The identifying feature that most easily differentiates the two species is the presence of a shoulder hump. When a Brown Bear, such as a Grizzly, is walking or standing still, the hump on its shoulders is the highest part of the body and clearly visible. The shoulder hump is all muscle and is used to help power the front legs to tear things apart and dig for food. Black Bears also rip into objects and dig, but for some unknown reason, they lack a shoulder hump.

Names of distinction

People reference bears by formal and colloquial names. A boar or he-bear is an adult male. A sow or she-bear is an adult female. A young bear, of course, is called a cub. A group of bears is known as a pack, sleuth, or sloth.

Ursa is Latin for "bear." "Bear" comes from the Old English name *bere*, which has its roots in an Indo-European word for "brown animal." The nickname "Bruin" comes from the name of a bear in an old French tale. "Grizzly" originates from the Anglo-Saxon word *grislic*, meaning "horrible," as in bad temper. We also use the term to refer to the grizzled appearance of the long, silver-tipped guard hairs of Grizzly Bears.

Brown Bear

Brown Bear

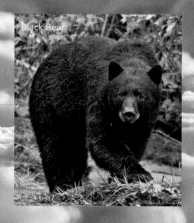

Black Bear

Sizes north to south

The largest of the bears, the Polar Bear, lives in some of the coldest parts of the world. Polar Bears are big partly because of their need to keep warm in ice-cold weather. The greater the body mass, the easier it is to retain heat and stay warm; the smaller the body mass, the easier it is to lose heat and stay cool. Thus, the farther north the latitude and the colder the climate, the larger the body mass will be. This association of size and latitude holds true for many animal and bird species, not just bears.

Brown Bears vary in size in their long range from Alaska to Wyoming. The most northern bears in Alaska and Canada tend to be the largest. However, Coastal Brown Bears along the coast and on coastal islands average about 800 pounds, while Brown Bears living far inland in the Yukon average around 350 pounds. Even though both are northern animals with larger bodies, diet plays a big role in their physical development. Bears that have access to a rich, abundant food source, such as salmon, attain a larger body mass due to the increased caloric intake. Inland bears living away from a steady supply of fish eat a lot of sedges and other greens as their main diet and are much smaller.

The relationship of size and latitude also applies to Black Bears. Black Bears in northern latitudes, such as northern Canada, are larger than those in Florida, not only because of the climate difference, but also because of the length of hibernation. Since northern bears must start hibernating earlier and stay in hibernation for a longer time, they need more fat reserves to make it through the winter. Their larger bodies make it easier to gain weight and retain the extra fat that is critical for their survival.

Considerations of weight

Polar Bears are not significantly larger than the Brown Bears on Alaska's coast and Kodiak Island. The largest Polar Bears and Brown Bears weigh 1,400–2,000 pounds. Grizzly Bears, which are the smaller Brown Bears in the United States, have a weight range of 900–1,000 pounds. Black Bears weigh 100–900 pounds.

Estimating the weight or size of a bear in the wild is difficult, especially if you don't see one on a regular basis. Animal weight is usually perceived to be much greater than the actual amount. For example, people will report a normal-size bear as the largest they've seen if the bear has surprised or threatened them. Black Bears weighing 150–200 pounds are often estimated to be at least 400 pounds. Some overestimate weight as much as 10 times, depending on the circumstance. Bears appear much smaller to us if there is no threat factor or when they are sleeping or being cute.

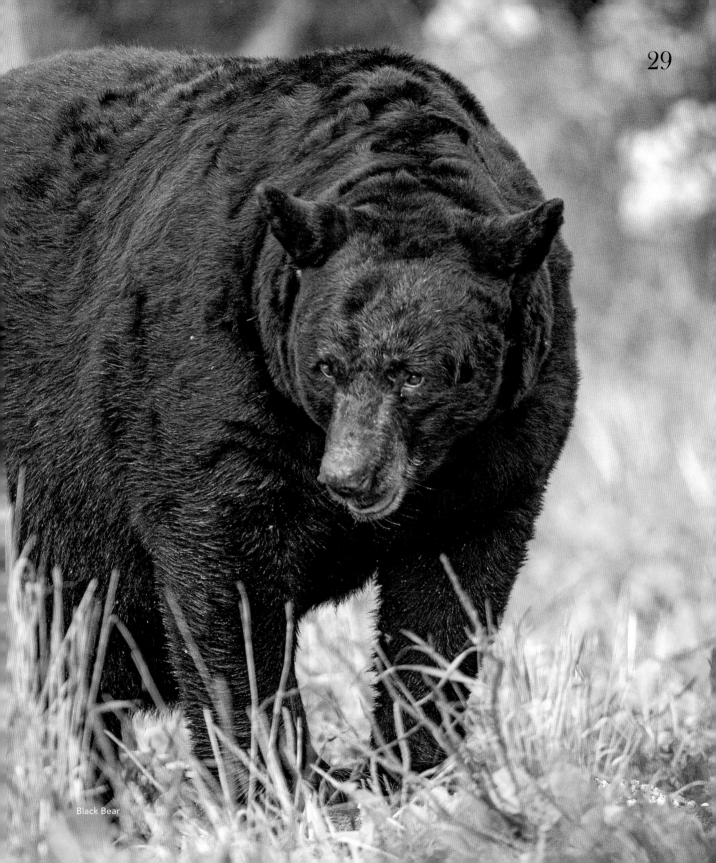

Black Bear

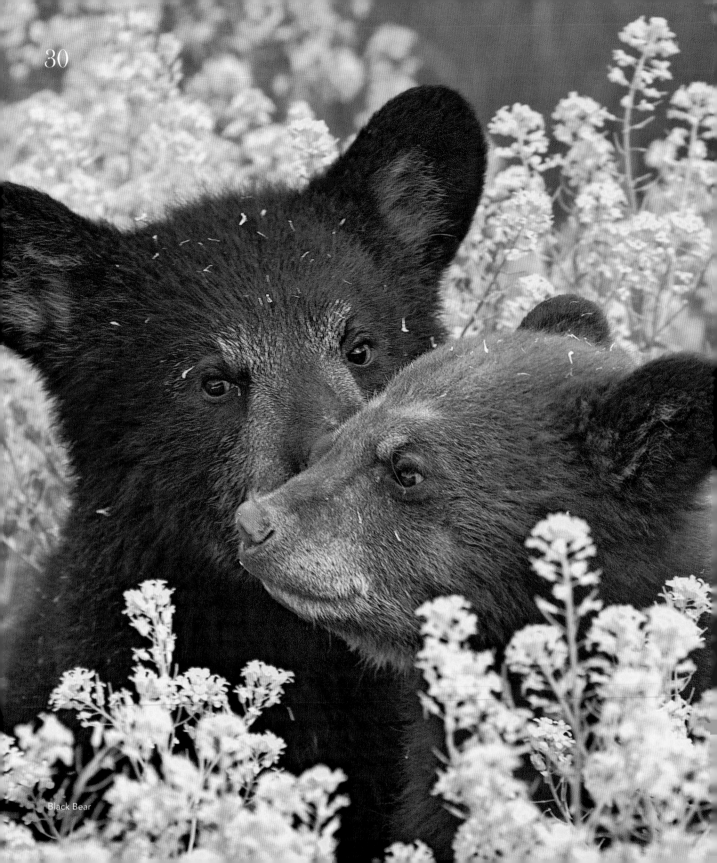

Black Bear

Life expectancy

Life expectancy in bears depends on many diverse factors. In cubs, the survival rate is less than 50%. This means that usually only one of two cubs will survive until it leaves its mother. Once a cub gets past 2–3 years of age, the chances of it living a long life increase dramatically.

Depending on the location, Black Bears can live 20–30 years. In heavily hunted regions, most don't make it to 8 years of age; others have made it to age 10, but this is rare. Captive Black Bears, on the other hand, live very long lives. It's not unusual for them to reach 40 years or more.

Brown Bears can live 30–40 years in the wild. One of the oldest captive Brown Bears lived into its mid-50s. Data about Polar Bears is not as abundant, but recent evidence shows that, like Black Bears in captivity, captive Polar Bears live well into their 40s.

No matter the species, one fact that remains the same is that most bears die as a result of human contact. These fatalities are from seasonal hunting or collisions with vehicles.

Roaming the home range

Unlike wolves and other large animals that defend a territory year-round, adult bears define and advertise a territory during breeding season. At other times of the year, they move around freely and often interact with each other without conflict.

Black Bears have a much smaller range than Brown Bears. Black Bear males move around an area of approximately 50–60 square miles, while females cover only 8–10 square miles. Brown Bears, including Grizzly Bears and Alaska's subspecies, have a range of about 100–200 square miles. These bears often stay in the region for long periods of time. Polar Bear ranges are upwards of 20,000 square miles.

Movement within a home range is based on available food. The more concentrated the food supply, the less the bears roam. When food is limited, bears search harder for meals and roaming increases.

Bears are remarkable navigators—far better than most other animals and certainly better than humans. Bears can travel great distances across many habitats without becoming lost. They remember the location of reliable food sources and, while avoiding humans and other dangers, will often journey many hundreds of miles annually to get to a treasured food source.

Coastal Brown Bear

Brown Bear footprints

Step-for-step paths

Bears are creatures of habit. They like to visit the same areas daily and often follow the same paths en route. In regions where bear density is high, they wear trails along streams and through the woods. Pathways used for generations result in extraordinarily well-worn trails, some with a groove up to a foot deep.

It's also common for bears to step into the tracks of other bears. Step-for-step paths indicate a favorite passage of many bears. Bears have scent glands in their feet, so as a bear moves, each step leaves a calling card. By stepping into the track of another bear, a new bear can cover the old scent with its own. In regions with high densities of bears, these step-for-step paths can be especially common.

Scent marking

Scent marking is very common in bears. About 90% of all communication among bears is achieved with scent marks. In general, males mark more than females. Bears mark by scratching, biting, rubbing against things, leaving footprints, urinating, defecating, and secreting chemicals from the anal gland onto objects or the ground. Most scent marking occurs just before the breeding season, tapers off during breeding season, and stops in late summer.

When a bear appears to be scratching its back against a tree, an important scent-marking event is taking place. The bear is leaving behind an odor, some fur, and physical damage to the tree for other bears to find. This combination of marks is an extremely effective communiqué and speaks clearly that a big male is in the area.

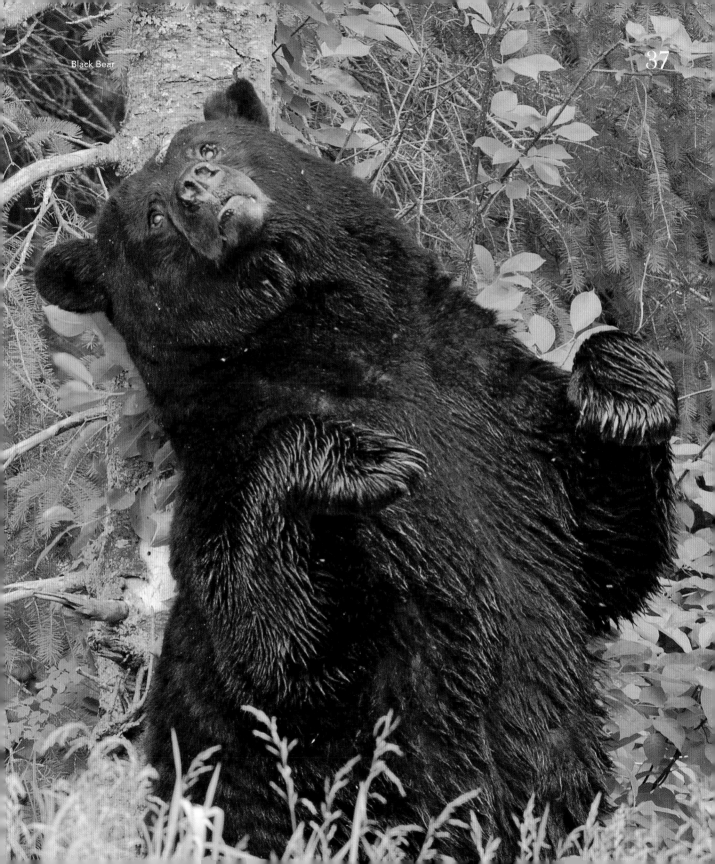

Black Bear

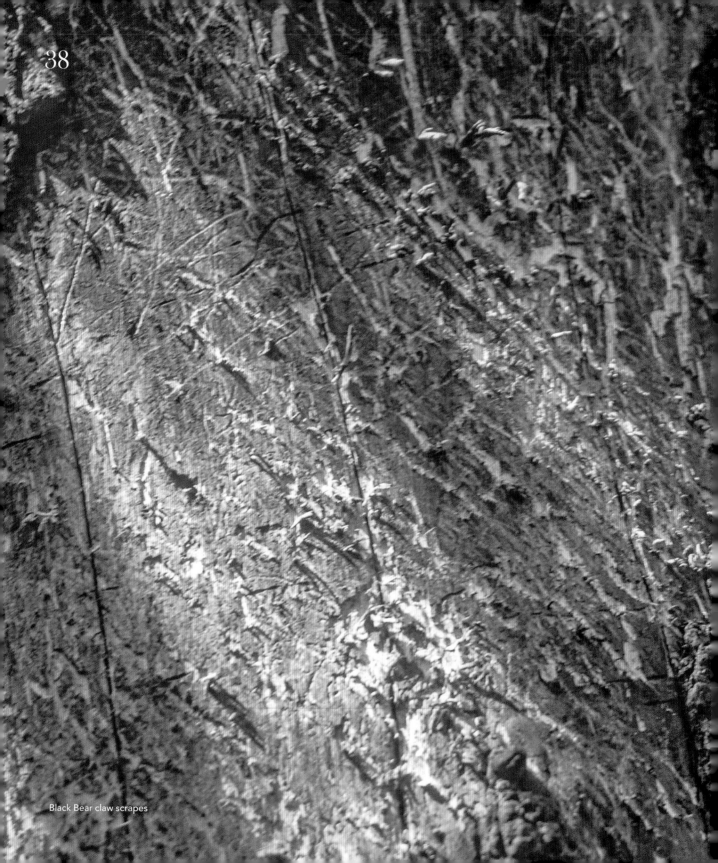

Black Bear claw scrapes

Claw scraping

Clawing is another visible sign of communication. Trees along well-traveled bear trails often have large claw scrapes. With the exception of large wildcats, only bears make this kind of mark on trees.

Theories abound as to the meaning of the scrapes. Male bears could be warning other males or establishing a hierarchy. Since smaller, subordinate males use these cues to avoid larger males, it may be a safe way for the larger bears to show dominance but to avoid actual fighting and injury.

Posturing to communicate

Body language in bears is a powerful means of communication. When combined with huffing, puffing, growling, or making other noises, posturing expresses exactly what a bear wants to say to other bears. When a bear is posturing, it is displaying its size, height, weight, head position, and stride.

Holding the head in a downward position demonstrates submissiveness or respect. Holding the head down while turning the body away shows submission as the bear considers its next action. Frontal or head-on body orientation means the bear is assessing the situation and is ready to become aggressive.

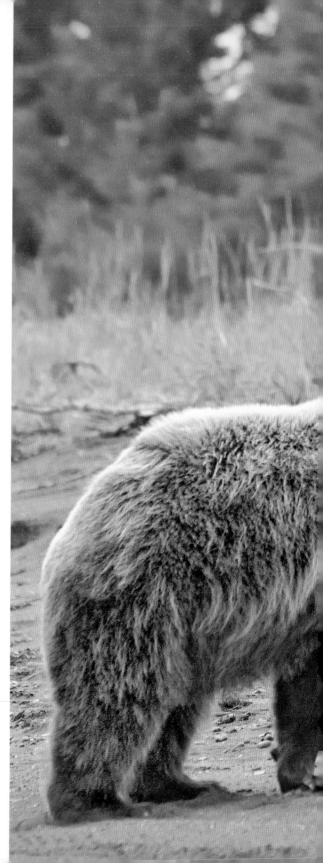

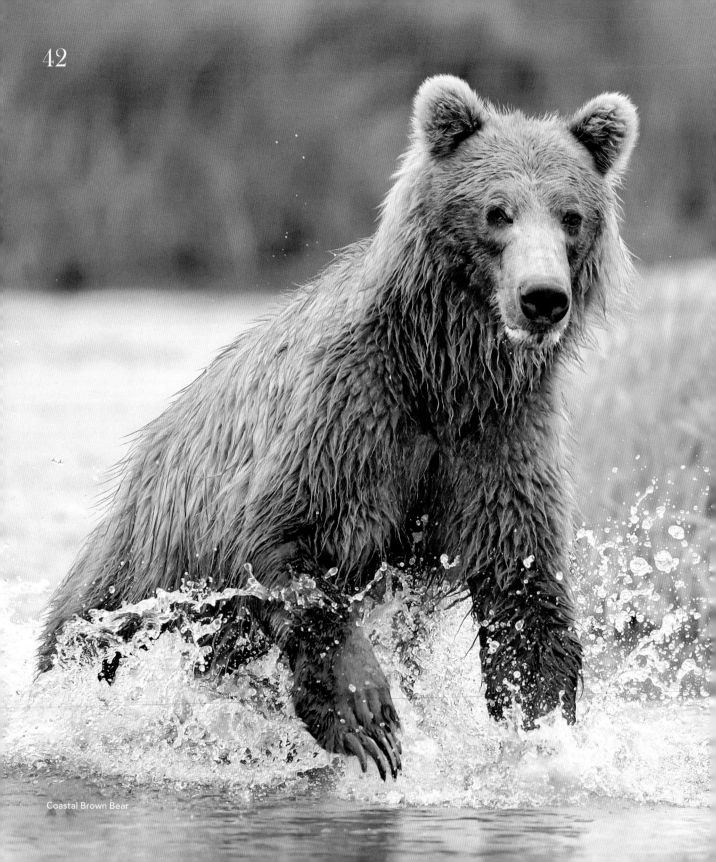

Coastal Brown Bear

Expression of aggression

Sitting on the hindquarters or lying down exhibits comfort and nonaggressive behavior. Bears that approach each other and relax on their haunches or lie down are obviously well acquainted with one another.

Stiff-legged movement while walking, running, or rushing forward, and circling while swatting things on the ground, are clear indications of aggressiveness. If you see any of these behaviors, the bear is dangerous.

Congeniality

Bears that are familiar with each other, such as adult siblings, will often interact. When familiar bears see each other, they typically move closer together with heads up, sniffing the air. Stopping a couple of yards apart, they sit down and watch each other while yawning and looking away. This conveys that they are comfortable in each other's presence. Afterward, they advance.

Congenial bears usually interact by play fighting. Play fights involve standing on the hind legs, grasping with the front paws, keeping the mouth wide open, and biting. The big difference between play fighting and real fighting is whether or not the bears make noise. Bears are usually quiet when they play fight. In a real fight, bears are very vocal. Additionally, most play-fight biting doesn't draw any blood, but minor bleeding can occur.

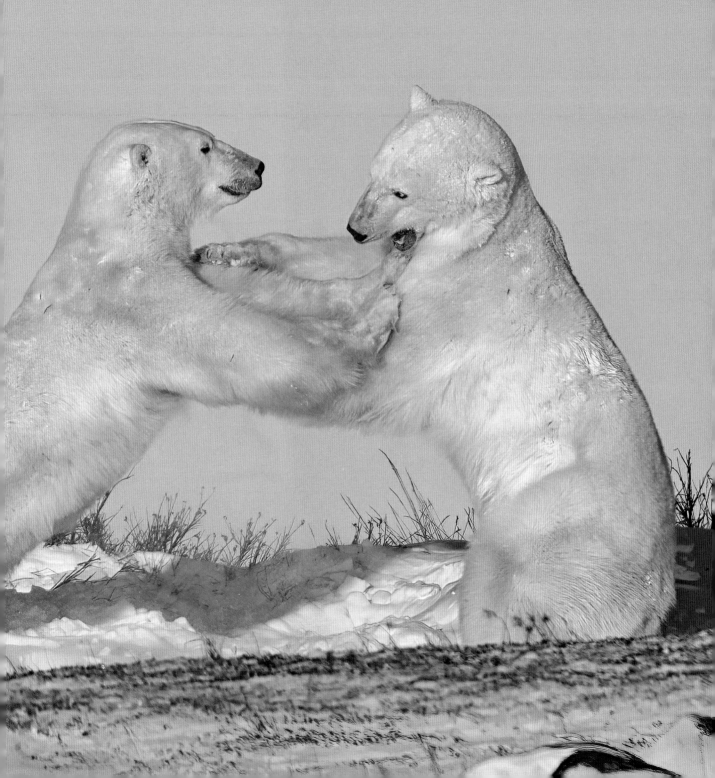

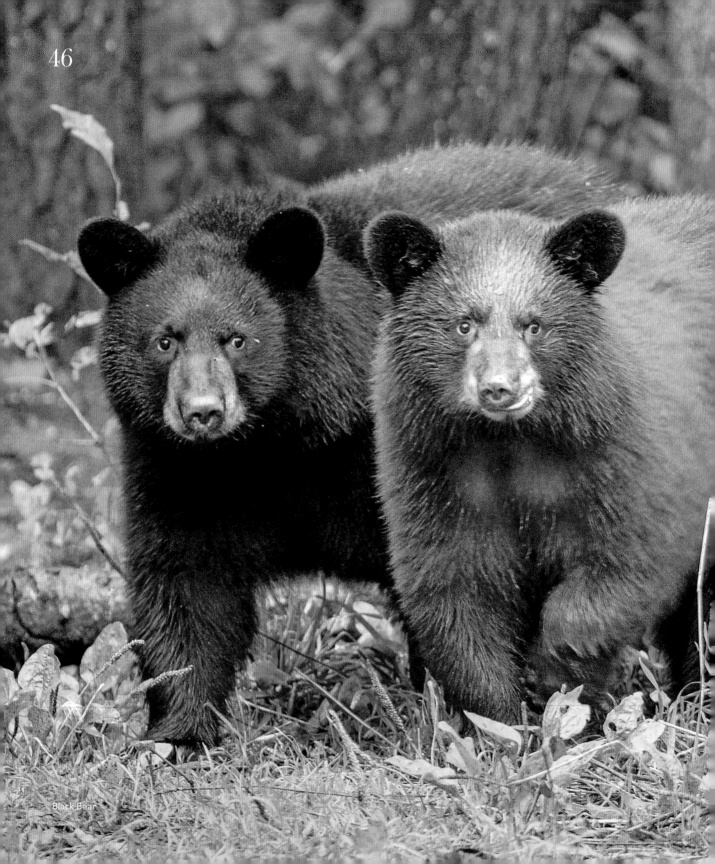

Black Bear

Not just smart—resourceful

Unlike other creatures with simple, predictable behaviors, bears are amazingly smart and complex. Bears have a high brain-to-body-mass ratio, and they're some of the most intelligent animals in all of North America. Bears possess the ability to solve problems, plan, show insight, and communicate. They are known to share resources and benefit from mutual security. They have hierarchies and interconnected relationships with other bears. Each bear is a unique individual with an identifiable personality. A bear remembers things it has learned over the years and puts the recollections to use in various situations throughout its life.

Large skull and jaws

The huge skull is perhaps the most important asset of bears. The skull protects the brain and includes a pair of large jaws, 42 teeth, and a long snout. Large muscles move the lower jaw and attach on top of the skull. The ridge on the back of the skull delineates the large surface area where the muscles attach.

Bears are omnivores that consume a wide variety of plants and animals. Brown Bears have large grinding teeth and jaw muscles. They usually don't need a powerful bite because they feed mainly on salmon and other soft-bodied animals. Polar Bears are the most carnivorous of bears, with skulls and jaws specifically shaped to deliver crushing bites to seals and other large prey.

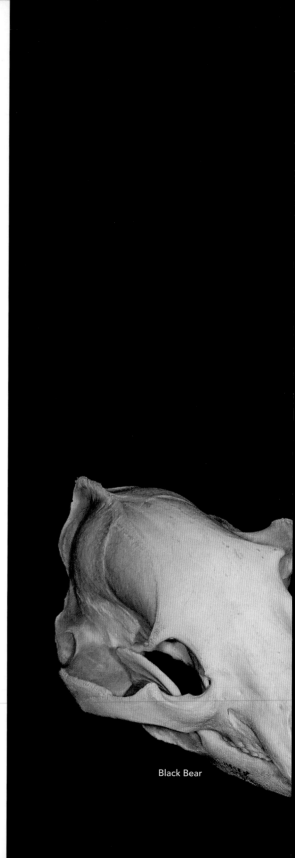

Black Bear

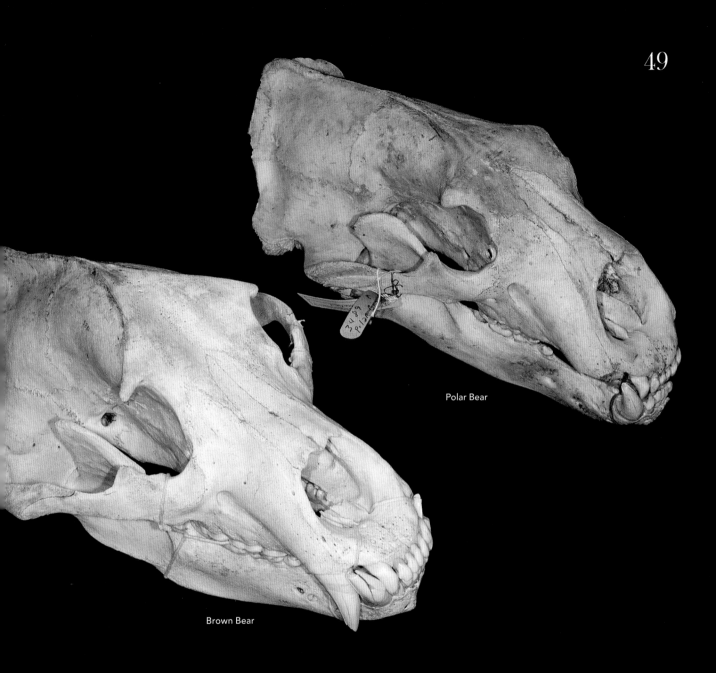

Polar Bear

Brown Bear

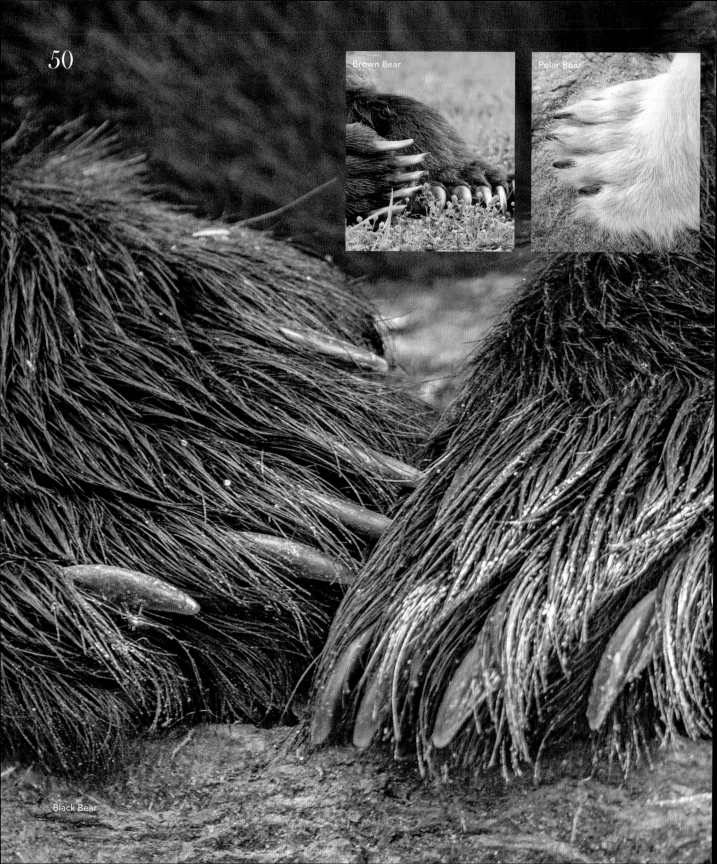

Brown Bear

Polar Bear

Black Bear

Claws and paws

Claws are one of the most notable parts of a bear. Bear claws are usually black, but ivory-colored claws are not uncommon. Bear claws are designed for digging, tearing, climbing, defending, fishing, and so much more.

Bears have long, curved claws that are nonretractable. This means that, unlike the retractable claws of a cat, they are fixed in an out-stretched position. Front-paw claws are much longer than those on the hind paws, with lengths varying among species and individuals. Black Bear claws are the most curved and only 1–3 inches long. Brown Bears have long, impressive claws that are about 5–6 inches in length. Polar Bears have relatively short claws that are mostly covered with fur, with lengths of 3–4 inches.

Bears use their claws for both delicate and heavy-duty jobs. Claws help bears scratch itches, extract clams from shells, dislodge insects from crevices, and reach into other small areas where their huge paws don't fit. Bears in search of food are able to turn over heavy logs and rocks more easily with their claws, and Black Bears depend on their stout claws to climb trees.

Claws wear down with everyday use, but they are constantly growing. The outer sheath peels away, exposing new growth beneath. Thus, claws are always sharp and ready for any task or defense.

Tiny tails

Interestingly, bears once had long tails, but these evolved into short tails several million years ago. All bear species now have stubby tails, perhaps to protect the anus. Compared with other land animals of today, bears have the shortest tails in proportion to their bodies. Like a fur-covered flap, the tail often goes unnoticed because it blends in so well with the surrounding thick fur.

The average length of a Black Bear tail is 4–6 inches. Brown Bear tails are 4–7 inches, and Polar Bear tails measure 3–5 inches. The smaller tails of Polar Bears have additional blood vessels and an extra layer of fat to prevent them from freezing.

Brown Bear

Polar Bear

Black Bear

53

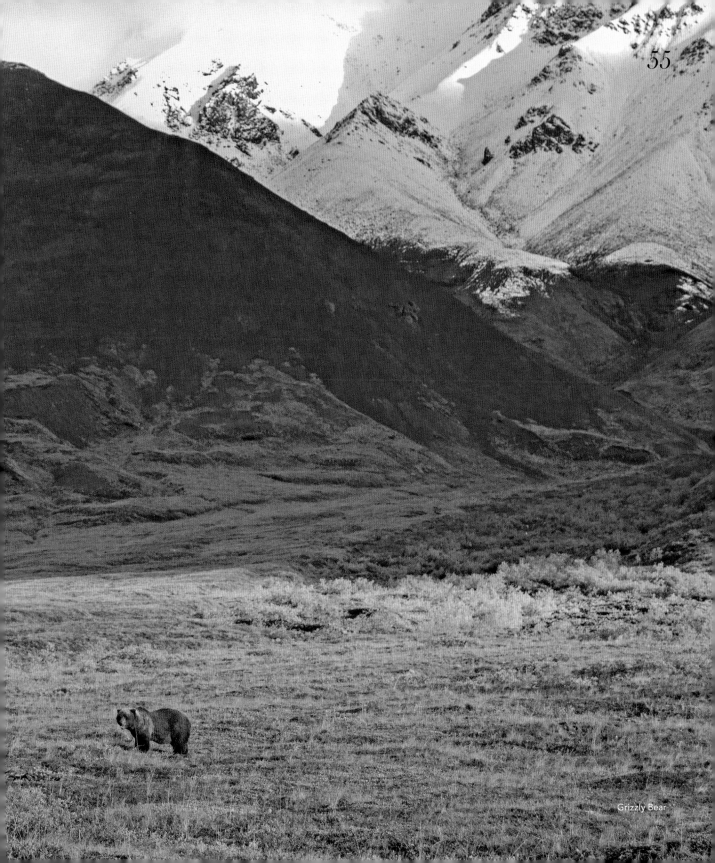

Grizzly Bear

Snouts and scents

No other mammal can detect a scent better than a bear. The ability to smell is about 7–10 times better in bears than it is in wolves, coyotes, and other canines, including domestic dogs, even bloodhounds. Bears use their sense of smell to find food, locate mates, recover wandering cubs, avoid aggressive bears, perceive human activity, and more. It is their most important and critical sense.

The long snout of bears has up to 100 times more mucosal membrane than the human nose and provides enhanced olfactory abilities. Also, bears can shift the tip of their flat, piglike snout from side to side to detect odors coming from different directions.

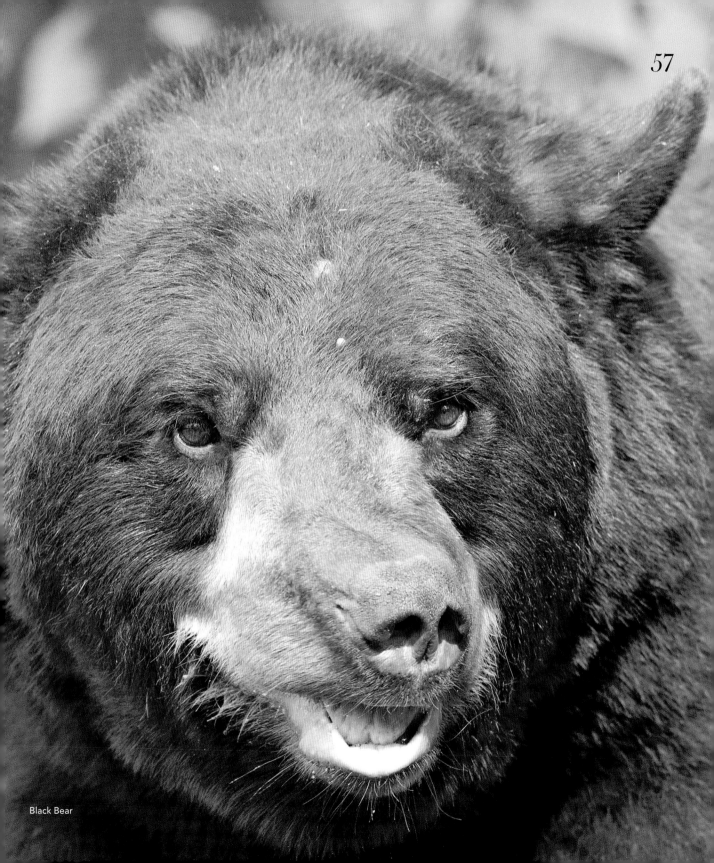

Black Bear

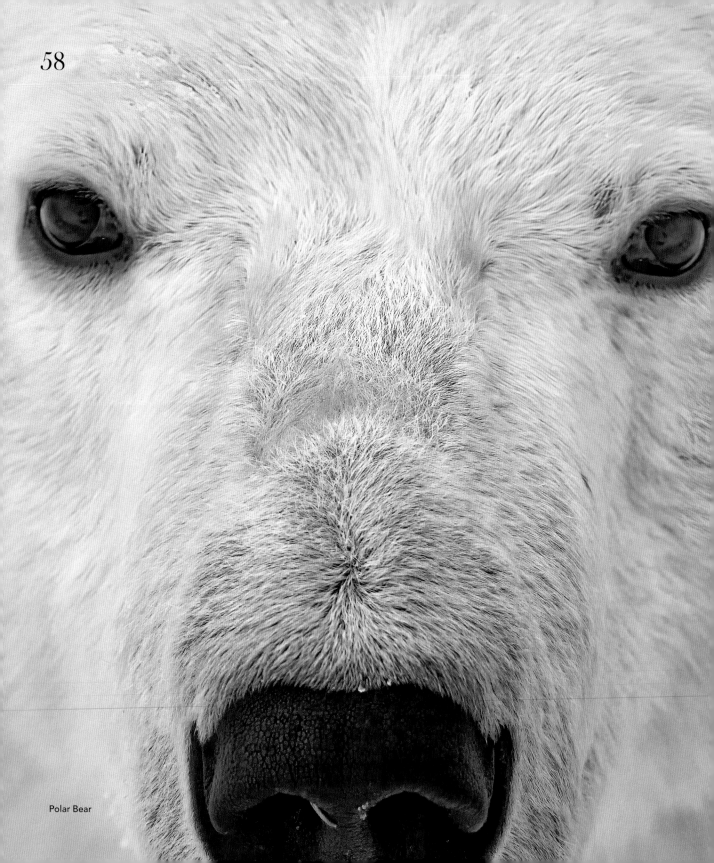

Polar Bear

Bears will follow their noses to carcasses. While photographing a pair of wolves with a fresh deer kill in Yellowstone, I saw a Grizzly Bear through my telephoto lens, nose in the air, walking in a zigzag pattern more than a mile away. There was no way this bear could see the wolves or the kill, but it obviously smelled the odors. It took about 30-45 minutes for the Grizzly to locate the site, charge in, and quickly steal the carcass.

Polar Bears apparently have the best olfactory sense of all the bears. Seals, their primary food, swim to the frozen surface and breathe air for a few seconds through small holes in the pack ice. It is thought that Polar Bears find seals by the scent of their breath passing through the holes. It would be very difficult for these bears to locate the seals without an incredible ability to smell.

Fuzzy ears, sharp hearing

Bears have small but visible ears. Black Bears usually have small, rounded ears that are set far apart on the head, with good to excellent hearing. Brown Bears have similar ears, although some individuals have oversize ears, and excellent hearing.

Grizzly Bears have the best hearing. They can hear a twig snap up to 300 feet away and probably can hear sounds in the ultrasonic range of 16-20 kHz as well, which is helpful for hunting pocket gophers, mice, voles, and shrews. Grizzlies listen for movement underground, quickly tear up the sod, and then pounce on the scampering prey.

Polar Bear ears are small, low on the head, and widely separated. This design helps them keep a low profile when they sneak up on seals. Their ears are also well furred, and the ear canals close tightly when underwater. Both of these features are adaptations to living and hunting in a cold, wet environment.

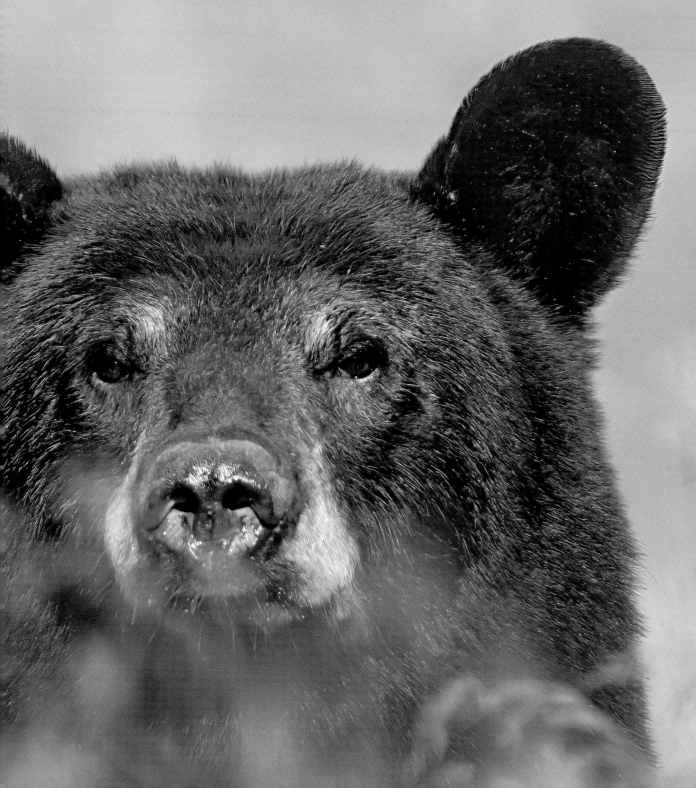

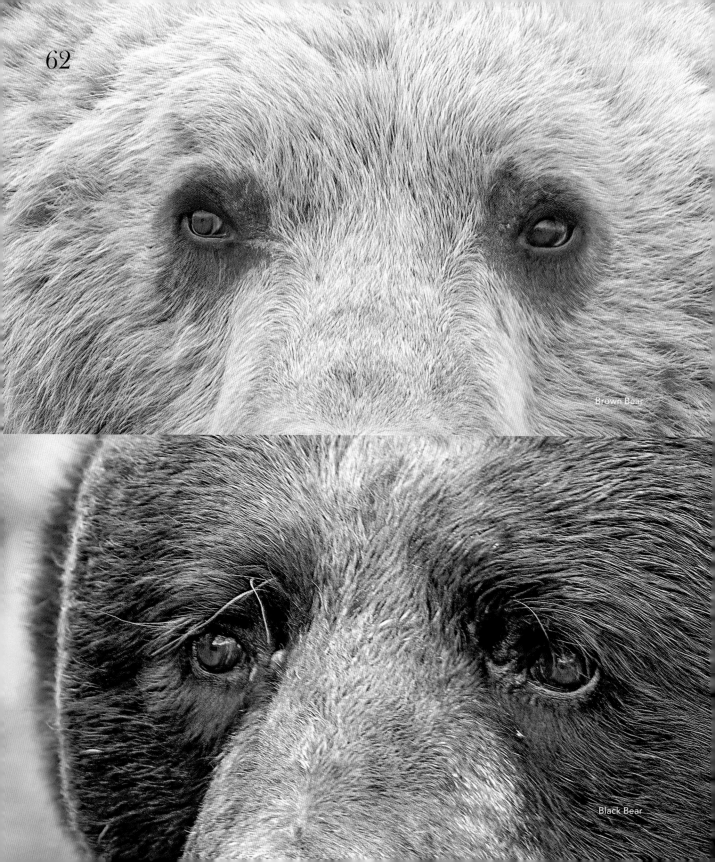

Brown Bear

Black Bear

Sight, near and far

Bear eyes are slightly smaller than human eyes. Compared to the large size of the bear skull, bear eyes are tiny, and the color of adult bear eyes is typically brown.

Bear vision is thought to be much like human sight, but the bear's ability to see at night is probably much better than ours. Eyes are positioned in front of the bear's head, providing for stereoscopic vision and depth perception. No doubt bears also see in color like we do, with excellent peripheral sight.

Bears may be nearsighted, meaning they can see objects clearly when they're near and not as well far away. Nearsightedness could be one of the reasons why bears often stand on their hind legs—to help them see greater distances.

Brown Bears have been proven to recognize objects over 300 feet away. Polar Bears recognize forms and shapes even farther in the distance, and they also have excellent underwater vision. In addition, they have an extra set of eyelids that protects the eyes underwater and helps filter snow glare.

Strong, stout legs

Unlike many other animals, bears have extremely powerful legs that are relatively short. Massive leg muscles enable bears to run fast and turn over large rocks, logs, and other heavy objects that stand between them and a meal. Besides that, tearing apart thick logs to dine on the insect larvae hiding inside requires strong legwork. Many bears also excavate their own winter dens, which often means moving a great deal of earth before hibernation.

Grizzly Bears are known for tearing up the ground to unearth voles and other small rodents. They rip up huge chunks of soil, which sends the small animals beneath scurrying in all directions. When the critters are exposed, the bear pounces like a coyote and gobbles down the meaty morsels. I have observed Grizzlies exhibiting this behavior and have been astonished at how quickly they move when chasing an erupted vole. Sometimes when watching through my telephoto lens, a bear will leap forward suddenly, giving the impression that it's right in my face—and often sending me back on my heels!

Grizzly Bear

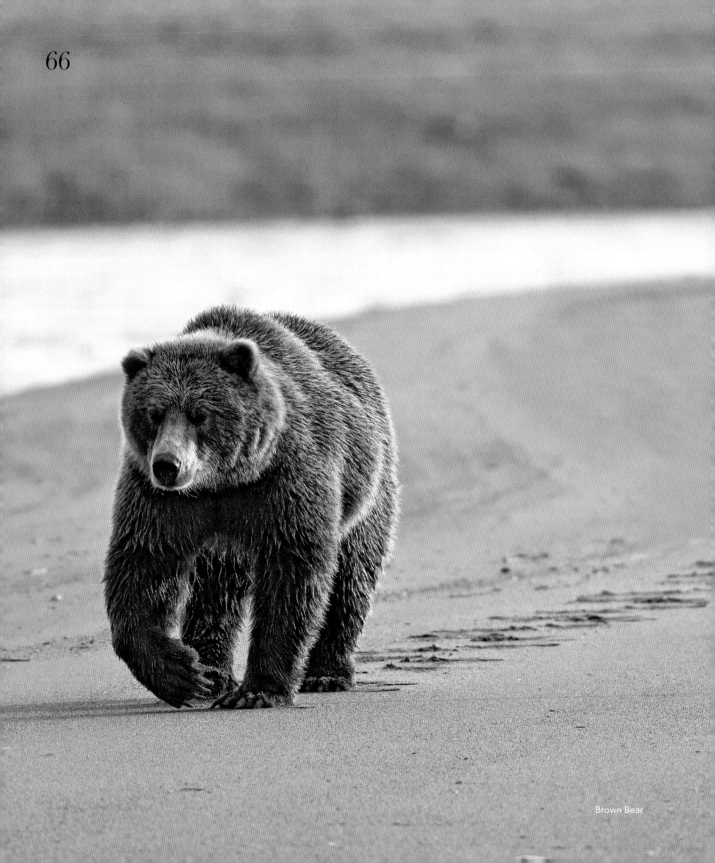

Brown Bear

Gait

Whether walking, running, or standing, bears are unusual when compared with animals such as deer. Deer hooves are equivalent to human toenails, so like ballerinas dancing en pointe, deer walk on their tiptoes. Bears, however, walk flat-footed, similar to you and me, with the soles of their feet on the ground. This gait is called plantigrade.

When a bear walks, the toes spread out in front of the foot. The long curving nails, which emerge from the upper part of each toe, touch the ground—but just barely. The right front foot moves forward at the same time the left hind foot moves up. As the hind foot begins to land on the ground, the left front foot moves forward. All of this makes a very characteristic track pattern.

Masters at running

All bears run incredibly well. In fact, bears are extremely fast but usually only for short distances and for brief periods of time. Bears can run ¼-½ mile in one burst and are completely worn out afterward. Some individuals have been known to run up to a mile before slowing down. While bears can maintain high speeds for only 5-10 minutes, reports of bears traveling at fast speeds and covering longer distances in 60 minutes are also common. Walking is a different story. Bears will trek hundreds of miles over longer periods in search of food.

A bear's speed of travel is crucial for catching prey. Black Bears can run 25-30 mph, while larger Brown Bears reach speeds of 35-40 mph. Polar Bears run as fast as 35 mph but quickly overheat, so they never run for very long.

To get an idea of how fast bears run, at 35 mph a bear can cover 50 feet of ground in 1 second. That means if a bear is 200 feet away from you, it will take only 4 seconds to reach you. That is not enough time to formulate a plan of escape, let alone execute it—which is why it is never a good idea to try to run away from a bear. Since bears can outrun racehorses over short distances, you would not be able to outrun a bear, even with a head start.

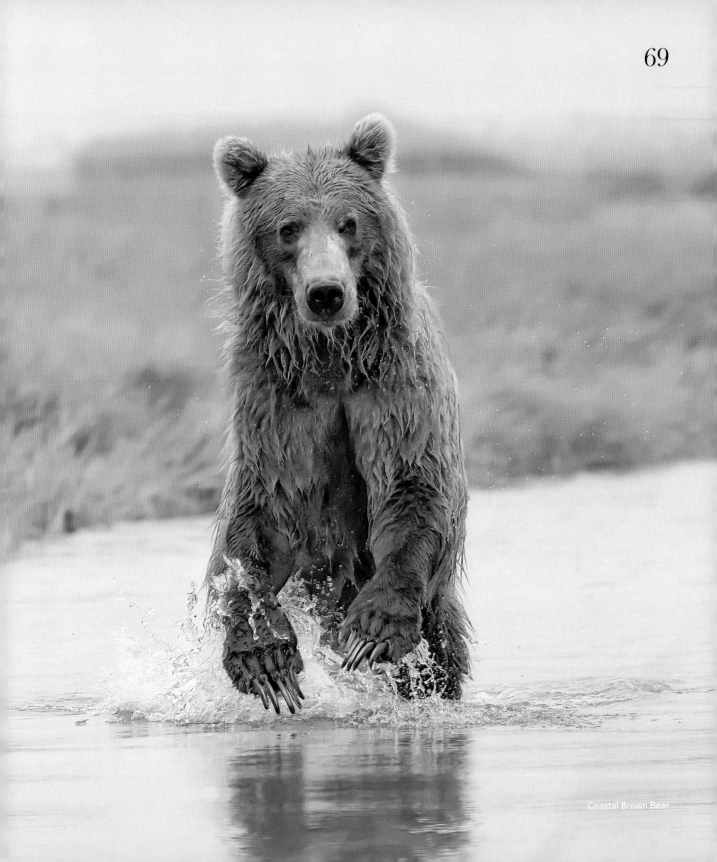

Coastal Brown Bear

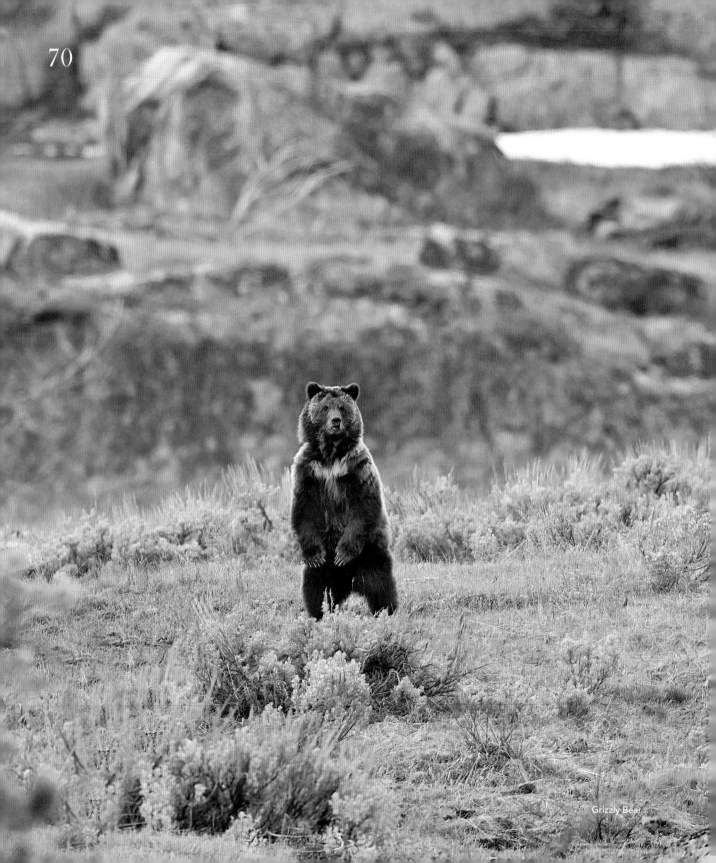

Grizzly Bear

Standing advantage

Bears are well known for standing upright on their hind legs. They usually stand to gain a visual advantage. Standing allows them to see farther or look over an object that is blocking their view.

Standing up doesn't always indicate threatening or aggressive behavior. A bear may be standing to eat. For example, Black Bears stand up to reach crab apples in trees. Bears also stand to scent mark trees by rubbing against them or scratching tree bark high up with their long claws. Polar Bears stand on their hind legs when playing and sparring.

Some bear species can also walk on two legs, called bipedaling. This is an abnormal way of getting around, though, and fairly uncommon. I once photographed a female Brown Bear in Alaska that was fishing for spawning salmon. Standing on her hind legs in the river, using the water's buoyancy to help keep her upright, she would walk around, looking for fish. The higher perspective from standing gave her a fishing advantage over bears walking in the water on all fours.

On land, bears don't travel far on two legs. They are capable of taking only a few short steps before falling forward and returning to four-footed travel. Additionally, bears don't usually attack from a standing position. When wrestling with one another during play, however, they will often stand up and lock their front legs together in mock combat.

Tracks and trails

Although the sight of huge Brown Bear tracks in mud is thrilling, the experience can be terrifying if you're not expecting to come across evidence of a bear. Tracks are as individual as human fingerprints. In all bears, hind paw prints are much larger than those left by the front paws. Black Bear tracks typically don't have claw marks. Their toes are loosely spaced in a slight curve over the main pad. Brown Bear tracks, on the other hand, often show claw marks. Their toes are close together and form a relatively straight line across the top of the main pad. Polar Bear tracks are usually indistinct due to the dense hair between the pad and toes.

From the size and shape of their feet to their short legs and large muscles, bears are traveling machines. When they're not hibernating, bears are constantly in motion and on the move, looking for their next meal. It doesn't matter whether a bear is grazing on green grasses or hunting newborn elk, the key to its success is covering a lot of ground.

Bears often travel the same pathways to and from their favorite feeding locations, and all bears in the area use the same well-worn paths for many generations. In regions of Alaska where bears were never exterminated, some trails have been used for 100 years or more.

When bears are moving about, they often take the path of least resistance. If they sense danger in the distance, they are most likely to move away silently. However, when they are startled, they often react by crashing off through the brush—or worse, they attack the intruder.

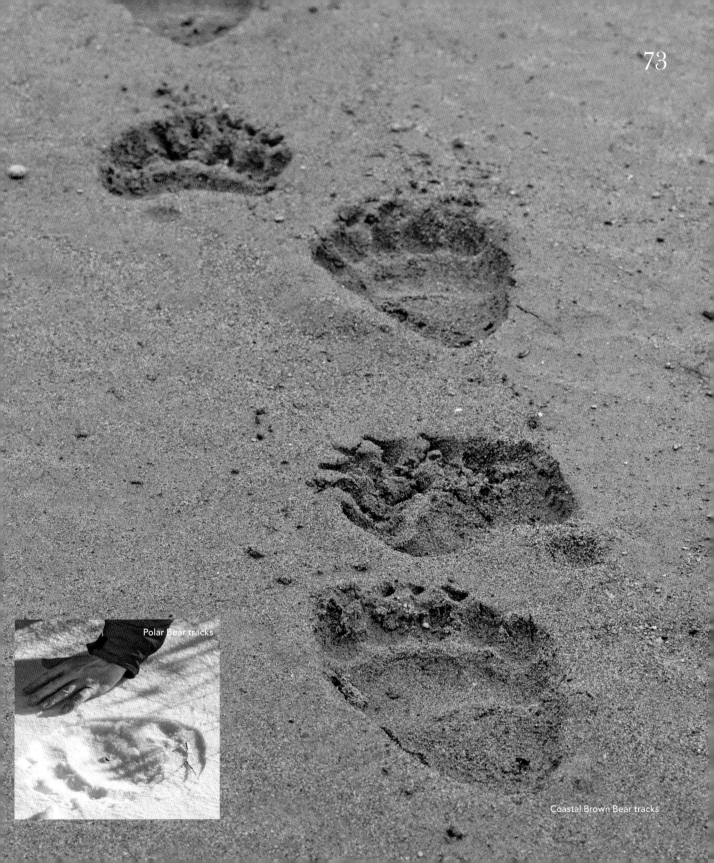

73

Polar Bear tracks

Coastal Brown Bear tracks

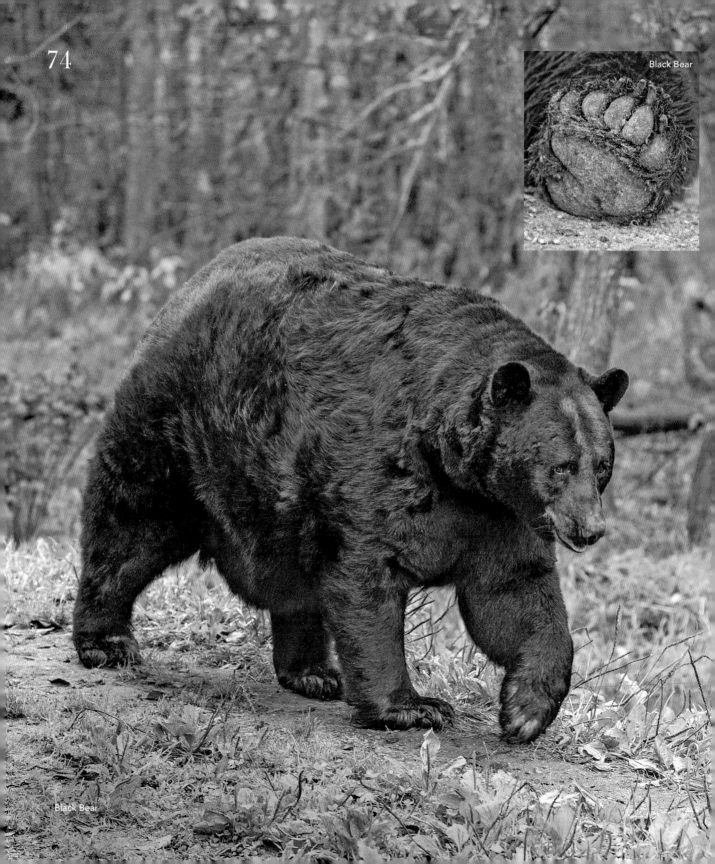

Black Bear

Black Bear

Silent travelers

It is astounding to think that bears are nearly silent when they walk, but it's true. I can't tell you how many times I've been surprised by a bear soundlessly walking up behind me. I've spent a great deal of time studying and photographing bears at close proximity, and the softness of their walk always amazes me. In fact, I usually hear breathing, grunting, and snorting before I hear evidence of footsteps. The large pads on their feet and thick fur outlining their toes help to mute their steps, especially on worn trails clear of dried leaves, twigs, and other debris.

When a bear walks, the movement is more like a shuffling or lumbering gait with turned-in, pigeon-toed feet. A bear scans the ground during travel, often holding its head below the shoulder line and swinging it back and forth, from side to side. The thick body and large shoulders make it appear that the bear is waddling—but don't let this fool you. Bears are very efficient walkers and runners, not just amblers.

Swimming trips

All bears love water and are excellent swimmers. Black Bears swim for pleasure and refreshment. In the summer, Black Bears will cool themselves in remote streams and isolated lakes.

Brown Bears are exceptionally strong and skillful swimmers. These bears often swim to catch fish, cross rivers, and move from island to island. Like Black Bears, Brown Bears also enjoy swimming for refreshment.

Polar Bears are the best swimmers. They travel from one feeding area to another, swimming as much as several hundred miles between ice floes. Their ability to swim for long periods is facilitated by a thick layer of body fat, which helps buoyancy. Their oily, thick fur keeps them waterproof and warm, and their huge round feet with partially webbed toes act like giant paddles. Geared for water travel, Polar Bears can swim up to 6 mph and journey up to 75 miles without taking a break. One individual in a study was documented for swimming nine days straight—truly an amazing feat!

Black Bear

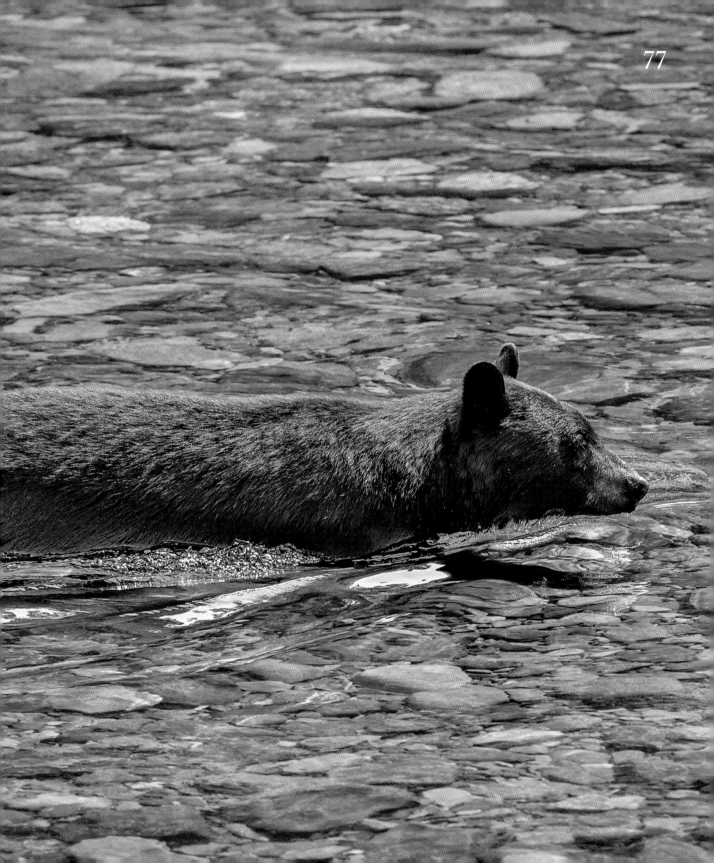

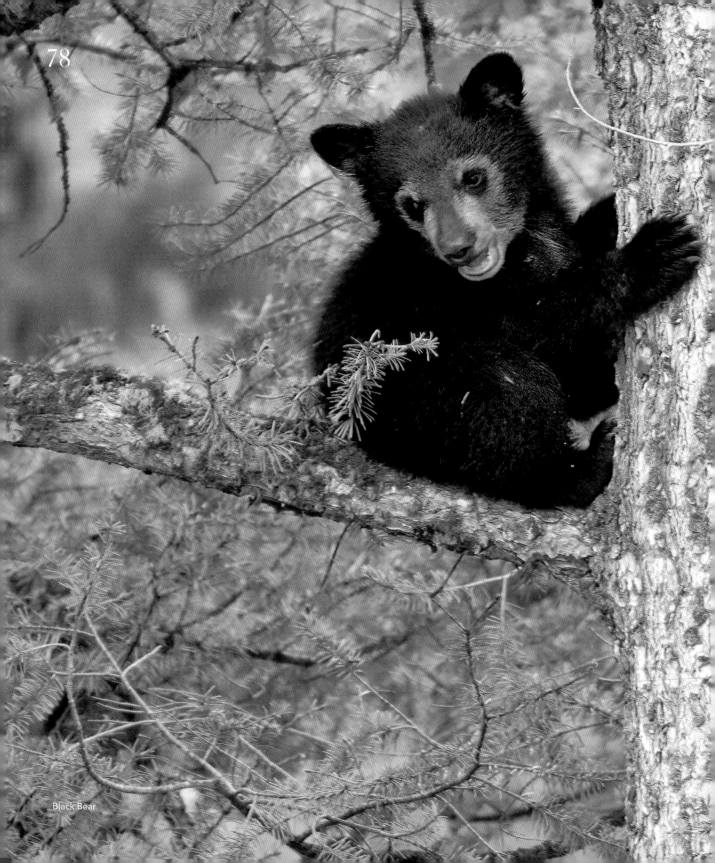

Black Bear

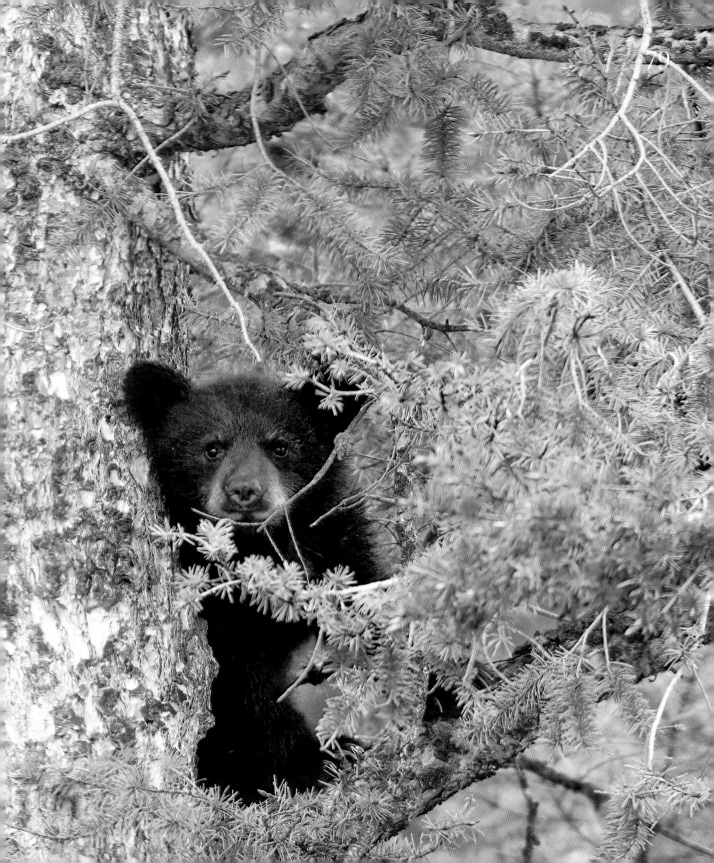

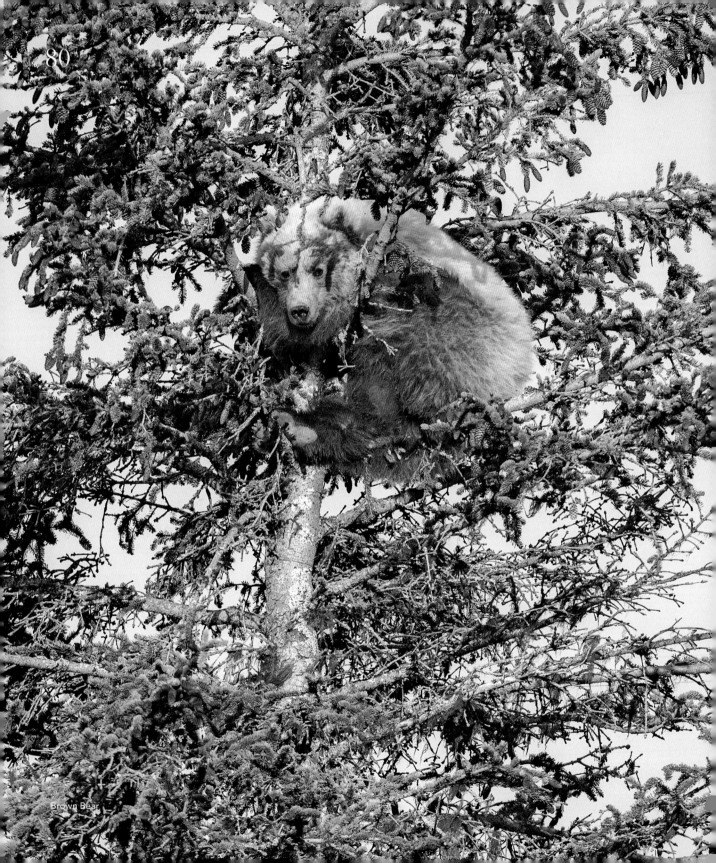

Brown Bear

Climbing trees

All bear species can climb, some to a greater degree than others, especially when it comes to trees. Black Bears seem to spend half their lives in trees. Tree climbing is second nature to tiny Black Bear cubs and mature adults alike. Brown Bears, including small cubs and adults, climb trees fairly well—they just don't make a habit of it. Polar Bears climb on and off ice blocks in the Arctic and may also possess the ability to climb trees, but they live in a habitat where trees only reach a few feet tall.

It's more accurate to say that a bear shinnies up a tree rather than climbs it. Bears travel up trees headfirst, grasping the trunk with the front legs while the hind legs push or thrust the body upward. Curved claws, such as those of Black Bears, are essential for this kind of climbing. Once the bear is up in a tree, it grips and holds on in various ways to get more comfortable.

The paws of Black Bears angle inward, greatly improving their ability to climb. Brown Bears have fixed wrist joints and long claws, so they often choose trees with a slight lean. However, they still will race up a bolt-upright trunk, especially when being chased by a larger bear. Sometimes large Coastal Brown Bears get so heavy that tree climbing is no longer practical.

Climbing down a tree is simply a matter of reversing the upward movement. Bears wrap their front legs around a trunk while walking back down, one foot at a time. When descending, a bear always holds up its head. Sometimes a bear will slide down instead of walking down the trunk.

Sleeping in trees

Young Black Bears spend much of their time in trees. They are so comfortable on the branches, they stay there to sleep. It's often comical to see tiny young cubs, as well as larger cubs, 1–2 years old, napping in trees. Often the mother climbs up and rests just below her babies to help protect them from dangers on the ground. Mothers will also sleep in trees.

Black Bear

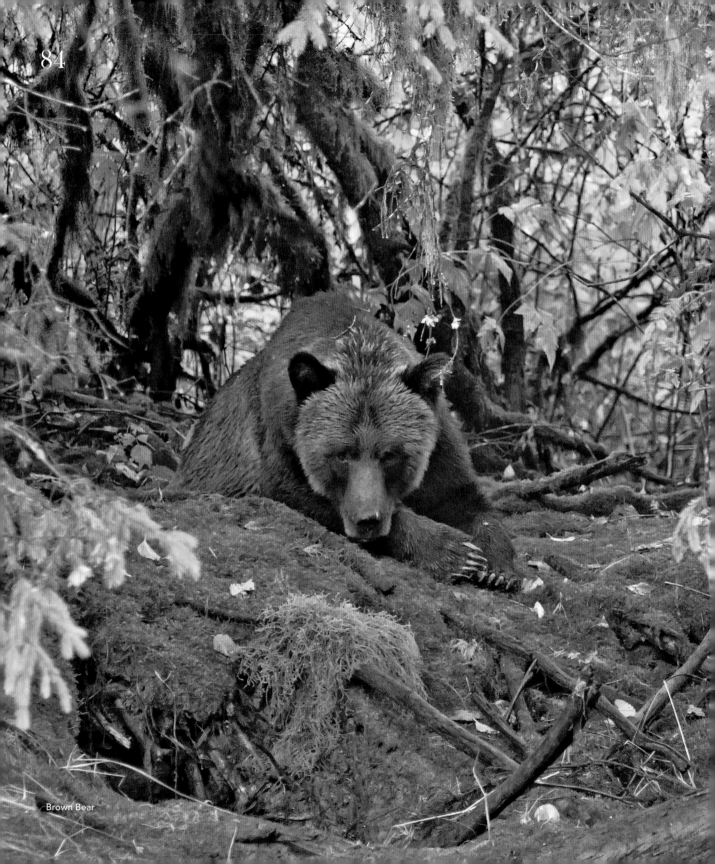

Brown Bear

Daybed naps

Bears often take breaks during the day to rest or catch a quick nap. Nearly all bears have a daybed near their favorite food source, and some may have several in their range. These are usually constructed of evergreen boughs, often in deep cover. Polar Bears dig into a snowbank to make a comfortable resting spot.

Play fighting

Few animals, including baby animals, spend as much time playing and wrestling as bears. Cubs are especially active with their siblings and mother in mock battles called play fighting. Play fighting lays the foundation for their survival in a dangerous world. It develops a bear's physical coordination and social skills, and it helps hone their escape skills, which will be essential later in life.

All young bears play fight until at least age 5 and beyond. Cubs that are play fighting will stand on their hind legs and "box" with each other while keeping their mouths open, showing their teeth. They also roll on the ground and bite each other's fur, although biting is always gentle. No sounds, such as snarling or growling, are made during play.

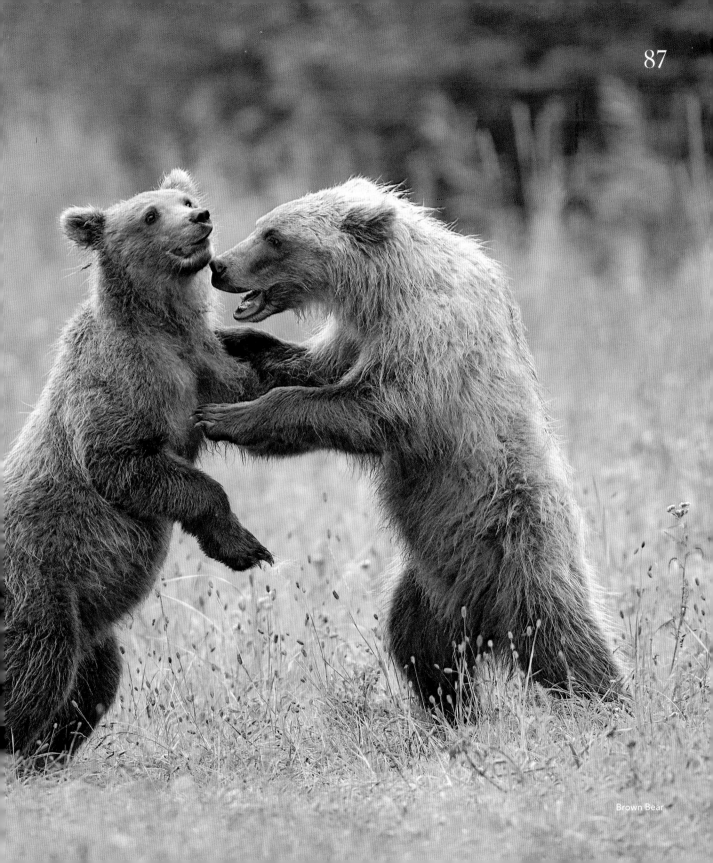

Brown Bear

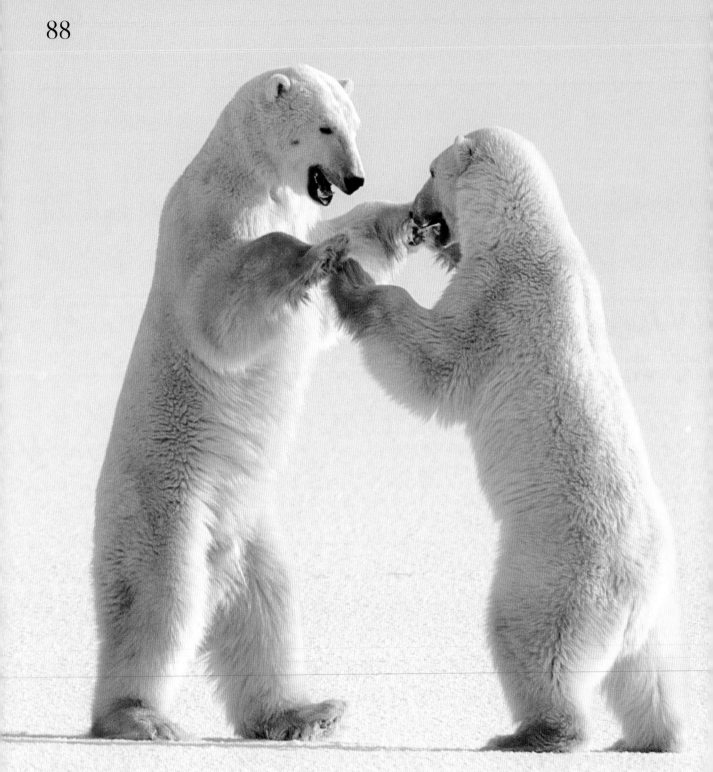

Polar Bear

Some cubs are naturally more playful than others, and well-fed cubs typically play more than hungry cubs. Play decreases dramatically after 18 months of age, which is when cubs leave their mothers and strike out on their own.

Adult play is usually limited to a mother and her cub. On several occasions I have observed as two adult Brown Bears approach each other from a distance and engage in play fighting. I suspect these bears are littermates that haven't seen each other in a while, and after reacquainting, they play as if it were old times. The exception might be Polar Bears. When subadults encounter each other, they often spend a lot of time playing.

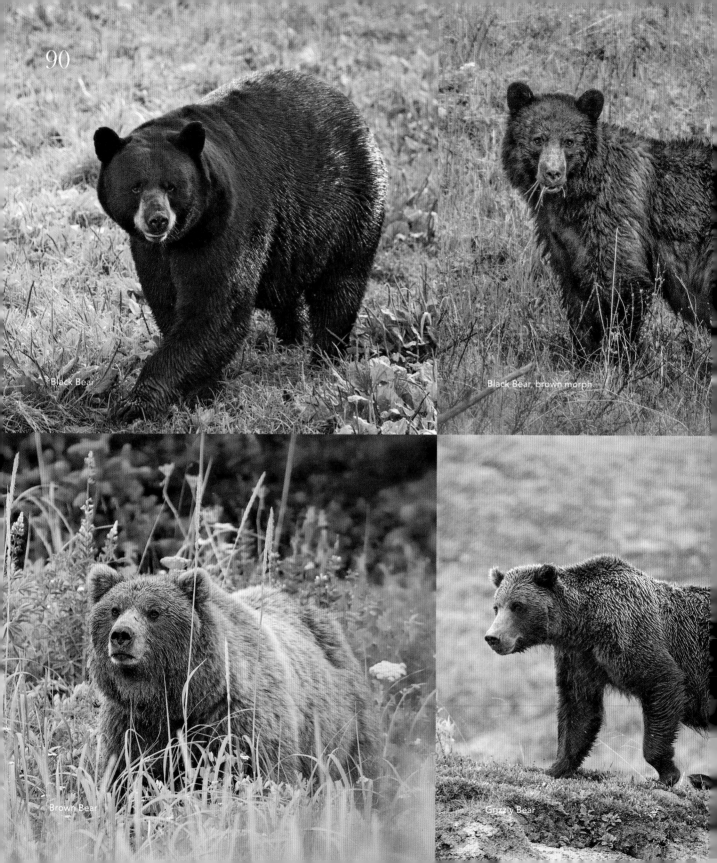

Black Bear

Black Bear, brown morph

Brown Bear

Grizzly Bear

Color palette

Fur color varies among the species, from black (Black Bears) to white (Polar Bears), and also within a species. Black Bear fur, for example, ranges from jet black to bluish purple and dark brown to cinnamon brown.

Black Bears have considerable geographical variation. About 70% of all Black Bears are black or very dark brown. Approximately 50% of Black Bears in the rocky Mountains are black, but this percentage increases as the range moves east. In New England and other regions with high moisture, Black Bears have black coats. The drier the habitat, the more brown the coat. In Arizona, one study reported that 94% of Black Bears in the state were brown.

Brown Bears are named for their overall fur color, but not all Brown Bears are brown. They range from dark brown to nearly black to silver. Grizzly Bears, a Brown Bear subspecies, have grizzled or silver-tipped guard hairs and often a silver band or stripe across the shoulders.

Furry coat

Another distinctive part of a bear is its fur. Bears have a densely thick fur coat consisting of two types of hair. The long outer hair, called guard hair, gives the bear its overall color. The second type of hair, known as underfur, is shorter and hidden by the guard hair. Underfur is thicker during winter and serves as the main insulating fur. It also helps bears stay dry while swimming and during rain.

Polar Bears have the most fur of all the bears. Except for the tip of their nose and the pads on their feet, they are completely covered in fur, with up to 4,200 hairs per square inch of their skin! Each hair is oily, hollow, and 3-6 inches long. Their fur coat is so thick that if you were to run your fingers through it, you might not even be able to feel down to the skin. This incredibly dense fur helps keep Polar Bears warm and waterproofed and is essential for survival in their environment.

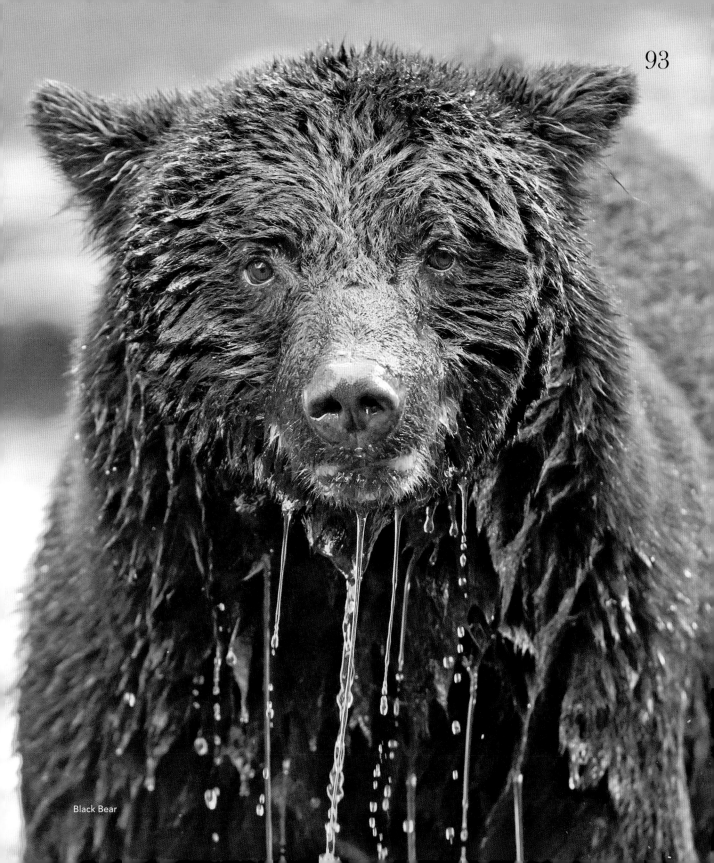

Black Bear

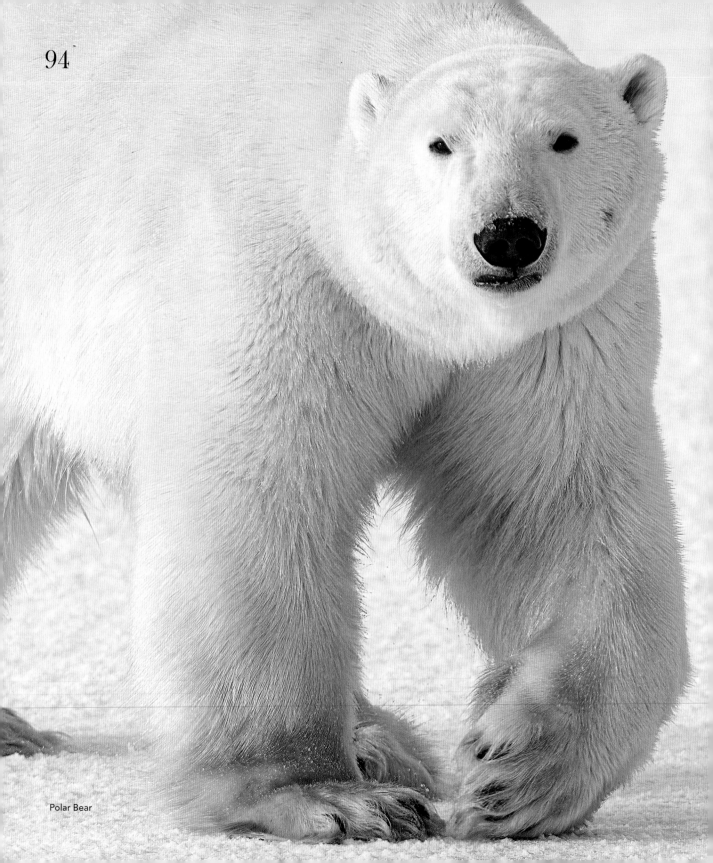

Polar Bear

Hollow hair

Biologists offer explanations to answer natural curiosities, including why Polar Bears have white fur. Besides the obvious fact that it helps them blend into a snowy environment, one theory is that their hair, which is hollow, is transparent, not white, making it easier to take in more light. Each hollow hair acts like a tube or straw, reflecting and scattering warm sunlight down to the Polar Bear's dark skin, which absorbs the energy. It is thought that a Polar Bear can change about 95% of the sun's energy to heat. The hollow strands of hair also trap warm air close to the skin, raising the insulating factor to a high degree.

Black Bear blaze

Black Bears can have what is known as a blaze—a white patch in the center of their chest or throat. The American Bear Association reported that 80% of all Black Bear cubs are born with a white blaze, but that it usually disappears as they mature. The report also stated that if a mother has a blaze patch, it's likely her cubs will have one too. A white blaze can be a good way to identify an individual in a sleuth or pack of bears.

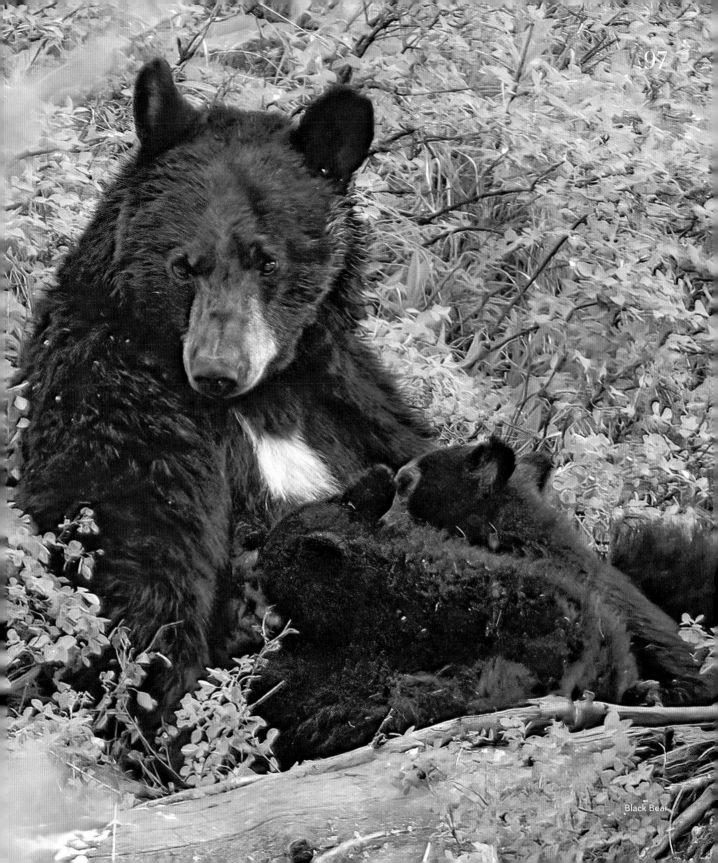

Black Bear

White, but not albino

Some Black Bears on the islands along British Columbia's northern coast have white or yellowish fur. These bears, known as Spirit Bears, are an unusual Black Bear subspecies, not albinos. There are perhaps fewer than 500 of these individuals on the islands, and they aren't found anywhere else in the world. I have been privileged to spend many days watching and photographing Spirit Bears catching salmon in the island rivers. The experience remains one of my most cherished encounters with bears.

Shedding

Bears molt their winter fur during spring and summer. They appear shaggy when shedding, with long patches of old, loose fur hanging from their coat as new hair grows in. Bears often rub against trees and large rocks to remove their winter fur, which also scent marks the area. While shedding, the shorter new hair grows longer. By fall, the bears have a healthy, luxurious coat of dense fur for the winter.

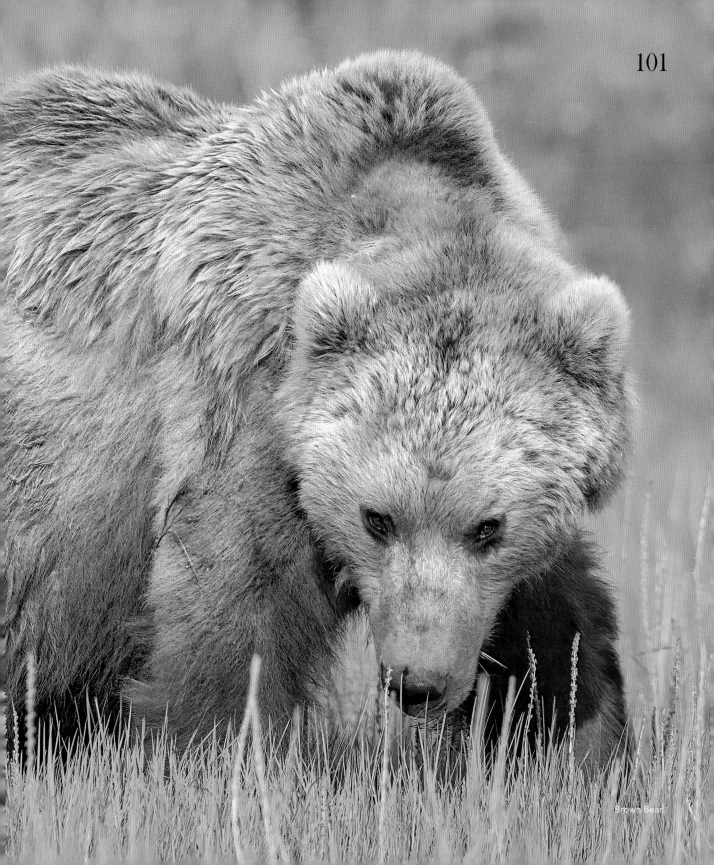

Brown Bear

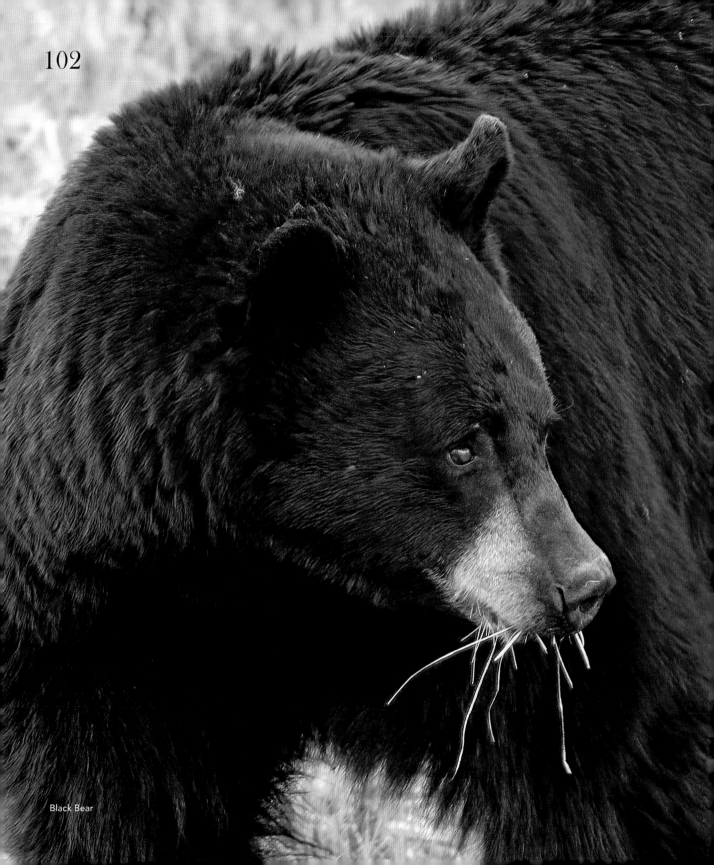

Black Bear

Potluck diet

Bears are omnivores, which means they eat both plant and animal matter. The main diet of Black and Brown Bears, however, is plants, with grasses, wildflowers, roots, shoots, and tubers among the staples. It is more accurate to describe these bears as seasonal feeders. They wander about as the seasons change, searching for new sources of abundant food. Normally, they favor fresh grasses and shoots in early spring and acorns and berries later in summer.

Bears remember the size, shape, and color of nuts, berries, and other nutritious foods. They spend more time each day looking for food than eating or doing anything else. Once bears find a plentiful food source, they often revisit it until the supply is exhausted. It's also not uncommon for them to return to the site annually.

About 85-95% of the Brown Bear's diet is vegetation. Brown Bears consume more than 200 species of plants, but usually only a small amount consists of fruit and nuts. However, in the higher elevations of the Rocky Mountains, about 75% of the Grizzly Bear's diet during late summer is whitebark pine nuts and tens of thousands of moths. Blueberries and other fruit are big favorites of theirs as well.

104

Black and Brown Bears are opportunistic meat eaters. Any meat in their diet is usually a result of finding roadkill or winterkill. In spring, Black Bears will take newborn White-tailed Deer, Moose, and Caribou. Grizzly Bears look for Mule Deer fawns and Elk calves. These primary sources of protein are available for only a short time because the young grow quickly and can soon outrun most bears. A seasonal abundance of spawning fish can provide the Coastal Brown Bears and Black Bears with ample food during the latter half of the summer.

Polar Bears are true carnivores, consuming about 99% meat. They prey primarily on Ringed Seals, obtaining up to 300,000 calories from each kill. In addition, they also eat birds and other marine mammals, as well as some plants. I have photographed them eating kelp and berries.

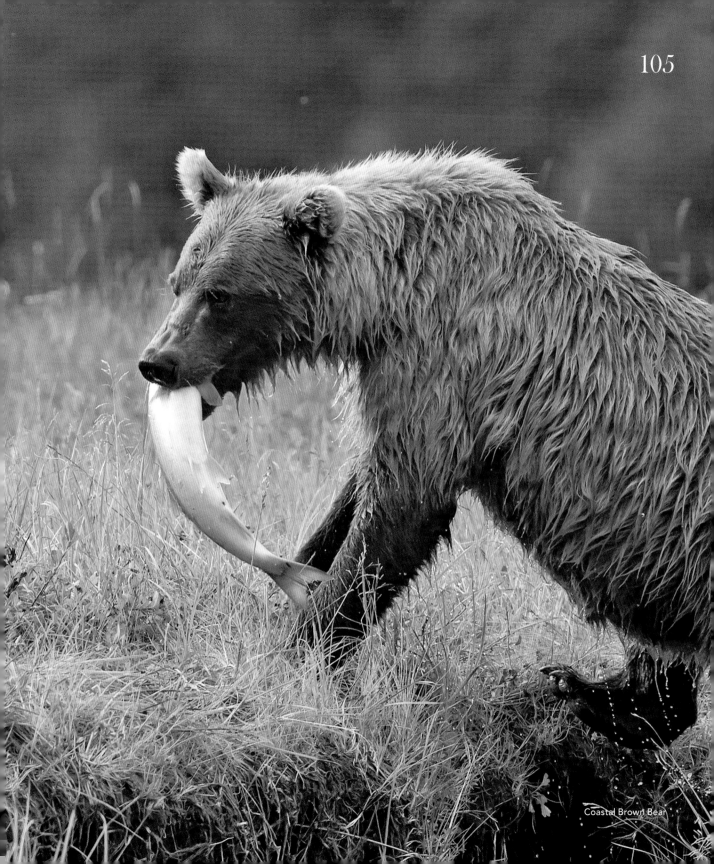

Coastal Brown Bear

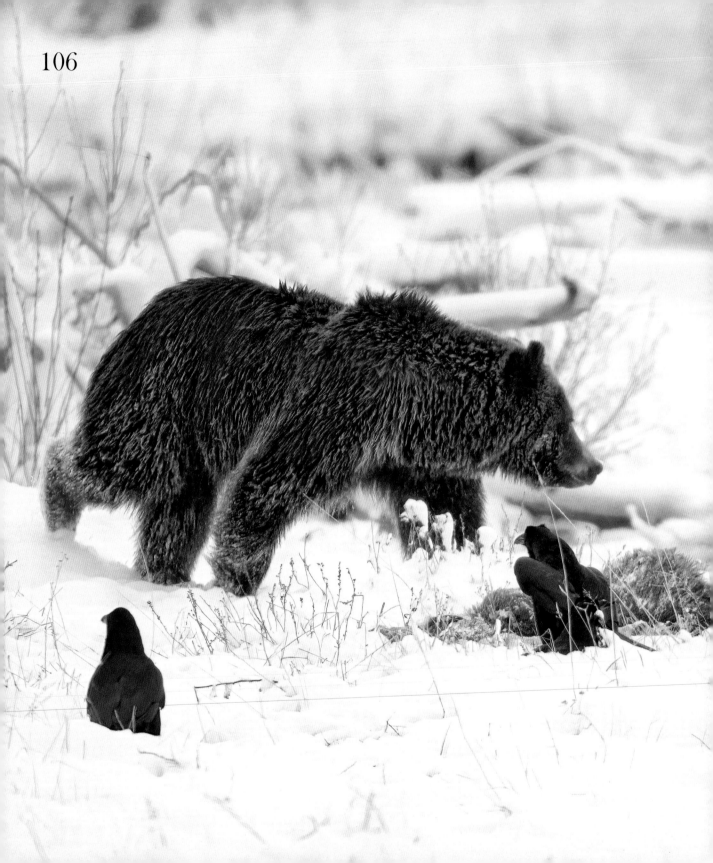

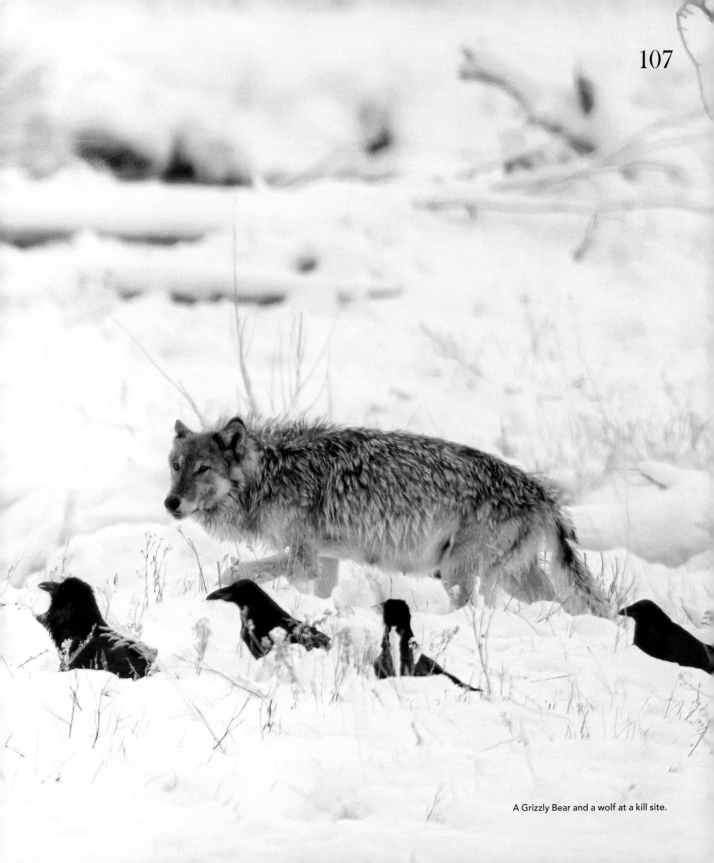

A Grizzly Bear and a wolf at a kill site.

Breeding time

Courtship in bears is the ultimate social interaction between normally solitary creatures. Their breeding season runs from spring to early summer. Polar Bears mate during May and June. In northern states, such as Minnesota, Wisconsin, and Michigan, the prime time for Black Bear mating is late May to early June. Farther north, in Alaska and Canada, Black and Brown Bears breed during June and July.

In all of our bear species, females don't become sexually mature until they reach 3–6 years of age. During mating season, sows come into a time of fertility called estrus, more commonly known as heat. In bears, estrus is limited from just a few days up to 1–2 weeks. Since bears can conceive only once each year, if they don't mate during this window of time, they have to wait until the following year to try again.

Male bears wander around during the breeding season, following their noses to find available females. They often reduce their food intake and can lose up to 20% of their weight during this time. Females are also more active, increasing their movement and giving off an inviting scent, which attracts males.

Not all females breed each season. For example, mothers with cubs are physically unable to breed. Also, because sexual maturation varies in young bears, a percentage of other females will not be ready to mate.

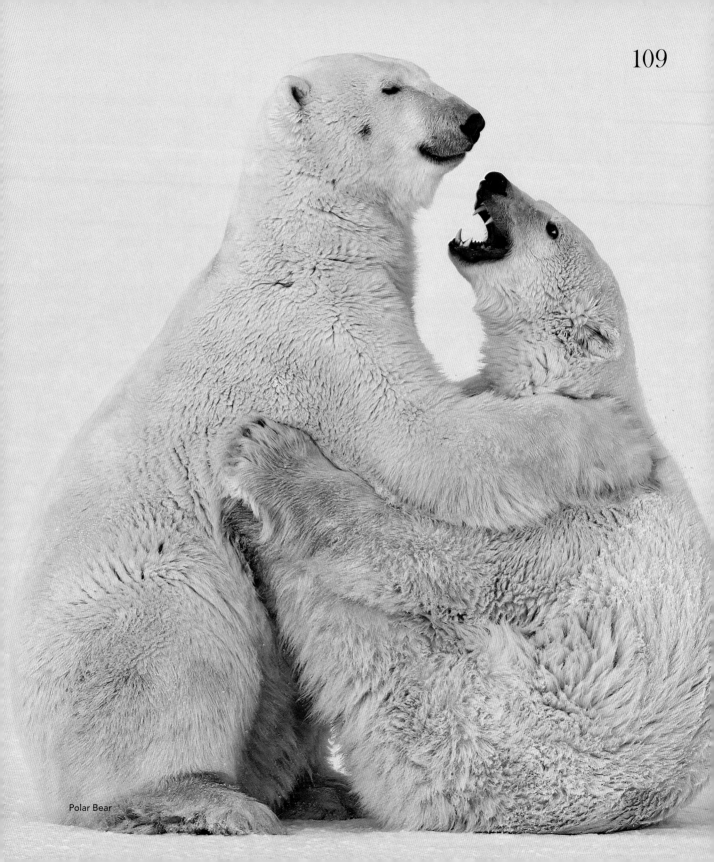

Polar Bear

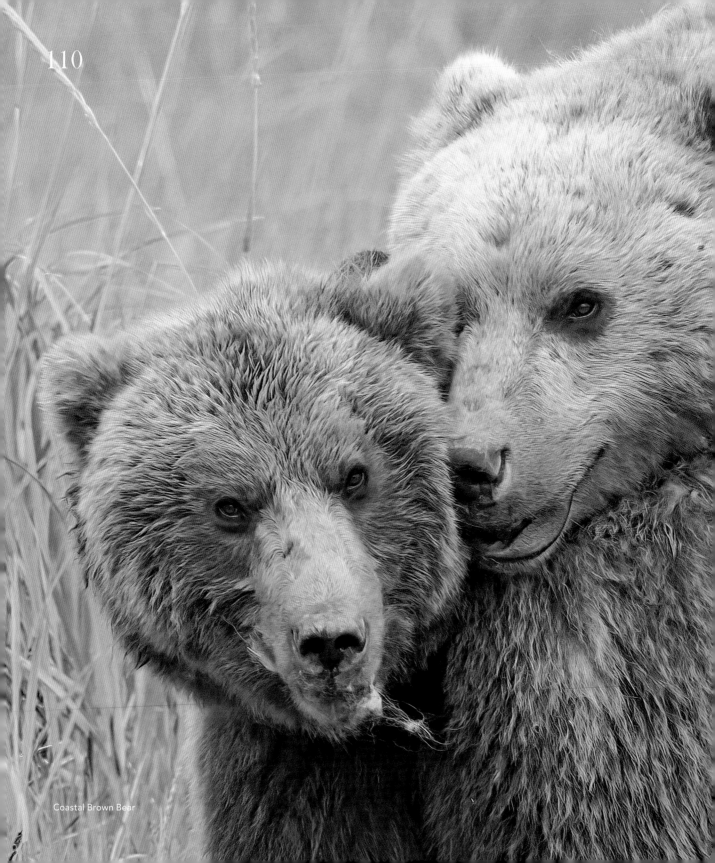

Coastal Brown Bear

Ready to mate

All bear species are polygamous. Males mate with many females during breeding season, and females mate with multiple males. When a male approaches a female in estrus, he may advance slowly at first and make different sounds, such as soft barking and clucking, while bobbing his head. However, I have seen males running at full speed once they get the scent of a receptive female.

When a male draws closer to an interested female, he may bite the fur around her neck. He will also try to rest his head across her back or shoulders. These are very tender moments. This interaction continues for a few minutes to several hours, or even up to many days—it all depends on the female's approachability. A male will wait for the female to become receptive, following her around for up to 10 days.

Eventually, the male perceives a signal from the female that it is time to breed. Often she will maneuver herself into position in front of the male. Mating is a brief affair, with copulation lasting 10-60 minutes. During this time, some bears are loud and animated. Others are quiet and demure. After successful mating, the male will often stay nearby for up to an hour, presumably to ensure that no other males pay the female a visit while fertilization occurs.

Unusual gestation

Although breeding takes place in spring and early summer, the birth of Black and Brown Bear cubs doesn't occur until the following January or February. Bears have an unusual gestation. After mating, the egg becomes fertilized, but it does not implant into the mother's uterine wall. Technically, the female isn't pregnant yet because the egg hasn't begun to grow. The fertilized egg remains in a suspended state of animation, with no cell division or growth until later. This time of inactivity is called delayed implantation.

Implantation of the fertilized egg depends on the female's fat reserves and general health at the end of summer, before she enters hibernation. If a female is in poor health or lacks enough fat to make it through a long winter, the egg is aborted and reabsorbed, and pregnancy does not occur. In a healthy female with sufficient fat, the egg implants and cell division begins, producing an embryo. Implantation usually happens in November.

Compared with other mammals of similar size, bears have a very short gestation period. The length of gestation in Black Bears is 180–240 days, starting from copulation. Brown Bears gestate for 180–220 days, although Grizzly Bears take slightly longer, 200–235 days. Polar Bears have an extended gestation period, 200–270 days, giving birth in December and January.

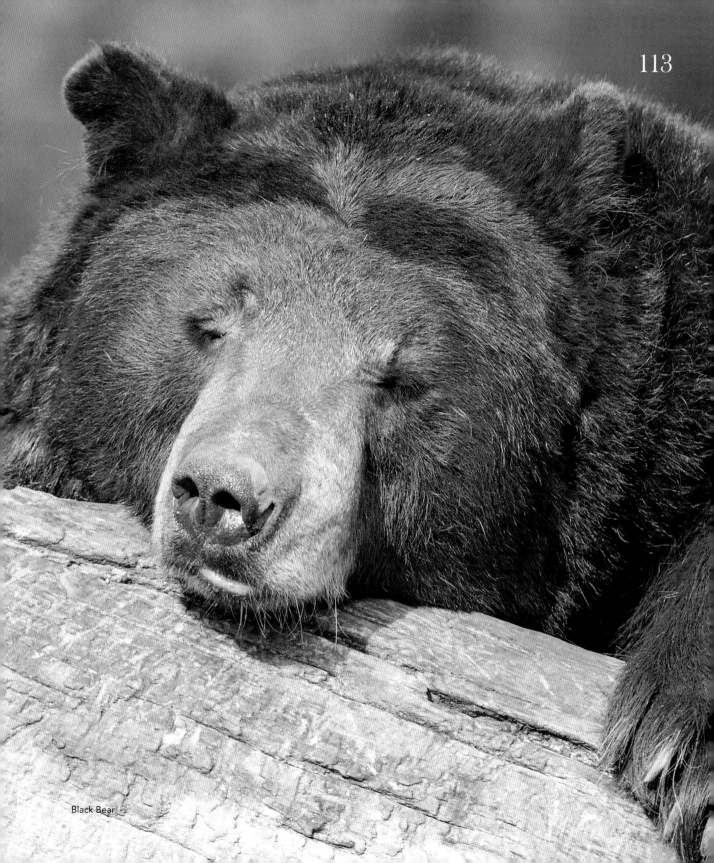

Black Bear

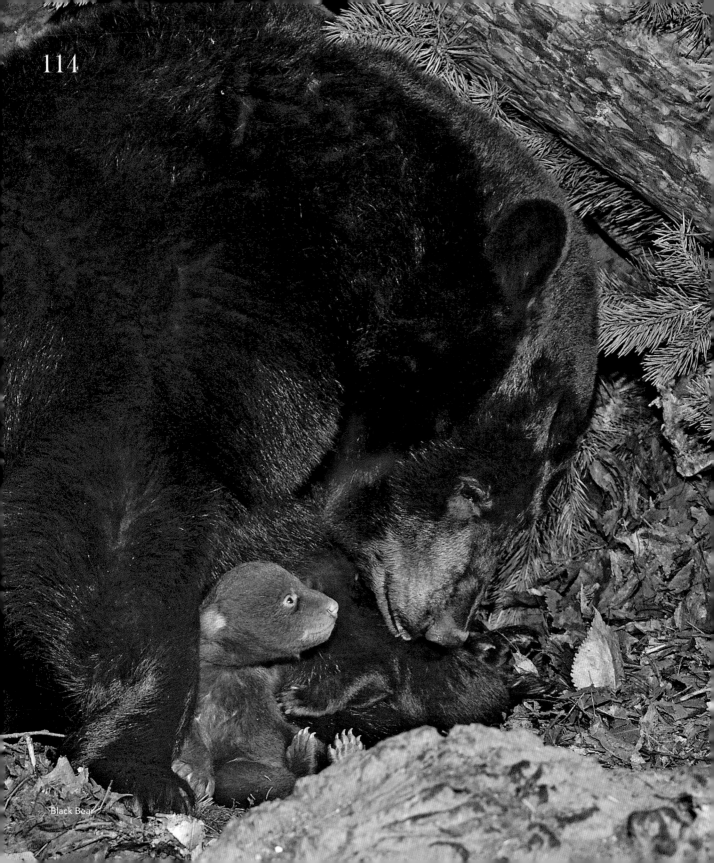

Black Bear

Birthing

All baby cubs are born in the den during winter hibernation. Pregnant females are alone in their dens and in full hibernation when birthing occurs. When a mother bear hibernates, she is not unconscious or oblivious to her surroundings. In fact, she is awake, with eyes open and moving about; however, she's in extreme slow motion, breathing only about twice per minute. Even so, she is able to tend to the needs of her newborn cubs.

Newborn and helpless

The short time in the uterus doesn't allow for much physical development prior to birth. Newborns are tiny, toothless, unable to see or hear, nearly naked, and helplessly uncoordinated. They rely on their mother's body heat to keep warm and need her help to find her milk. Tiny cubs are often noisy when nursing, giving a constant quivering vocalization that can be described as a sound of contentment. They are usually asleep and silent at all other times.

Black Bear newborns are just a fraction of their mother's size and typically weigh only 8-16 ounces. Grizzly Bear newborns weigh slightly more, 14-18 ounces, and Polar Bears are 16-24 ounces at birth. Black Bear mothers weigh a whopping 280 times more than their babies. Grizzly and Polar Bear mothers, which are larger than the Black Bears, weigh an incredible 700 times more than their young.

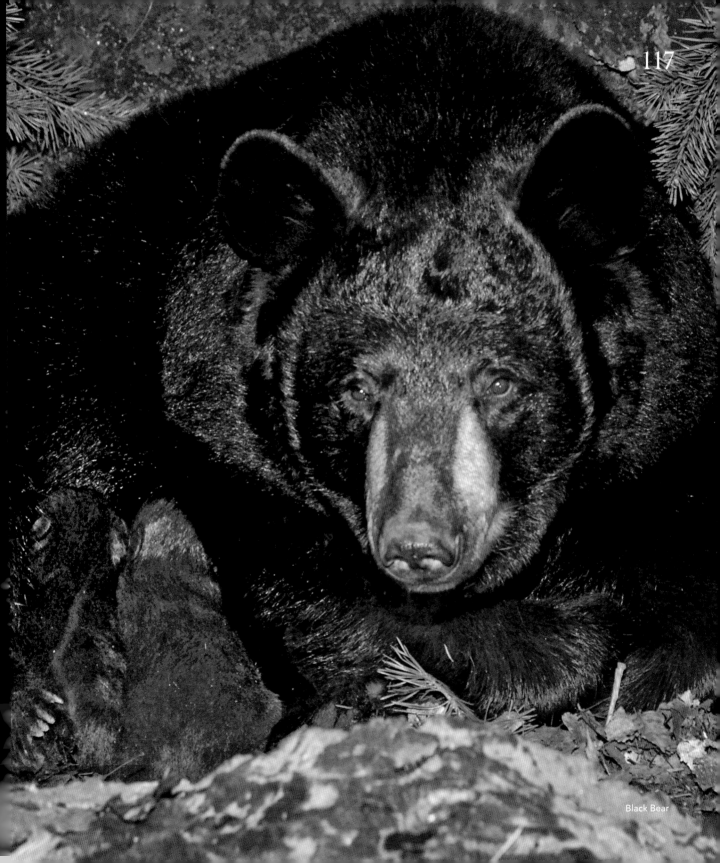

Black Bear

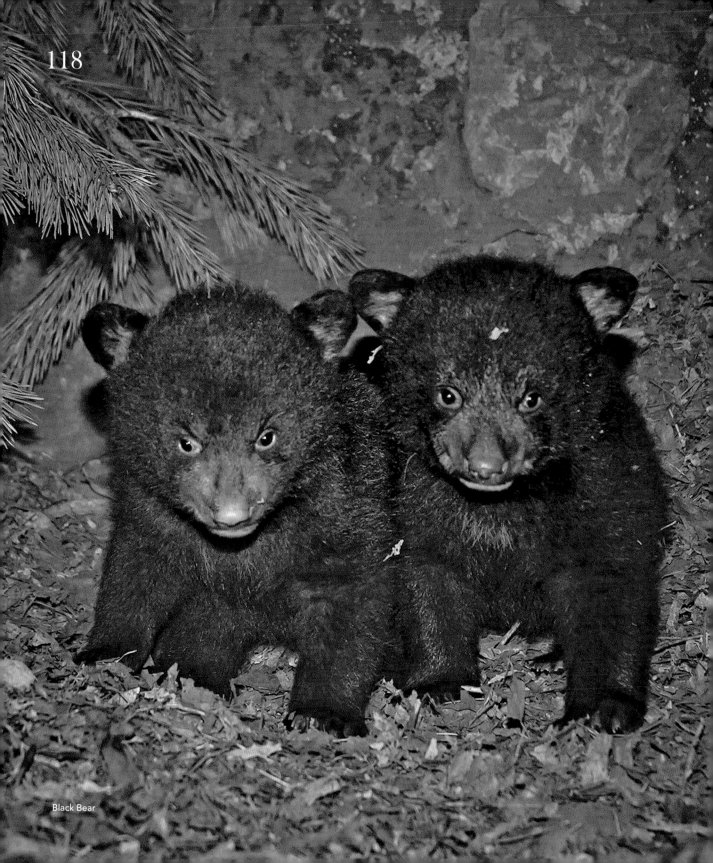

118

Black Bear

Eyes open

With their eyes sealed shut, newly born bears start their lives blind. Brown Bear and Polar Bear cubs open their eyes at about 28–32 days of life. Black Bear cubs are able to see at around 30–40 days. Black Bear cubs are born with bluish-gray eyes, but the color changes to brown within a few months.

Mother's milk

Bear milk is rich in fat and protein. Grizzly Bear milk, for example, provides more than 5 times as many calories as human milk; it has about 5 times as much fat and 17 times the protein, as well as additional carbohydrates. Bears in northern climates produce richer milk than those in southern climates. As you might expect, Polar Bears produce the richest milk of all. Polar Bear milk has the consistency of condensed milk, with the odor of fish.

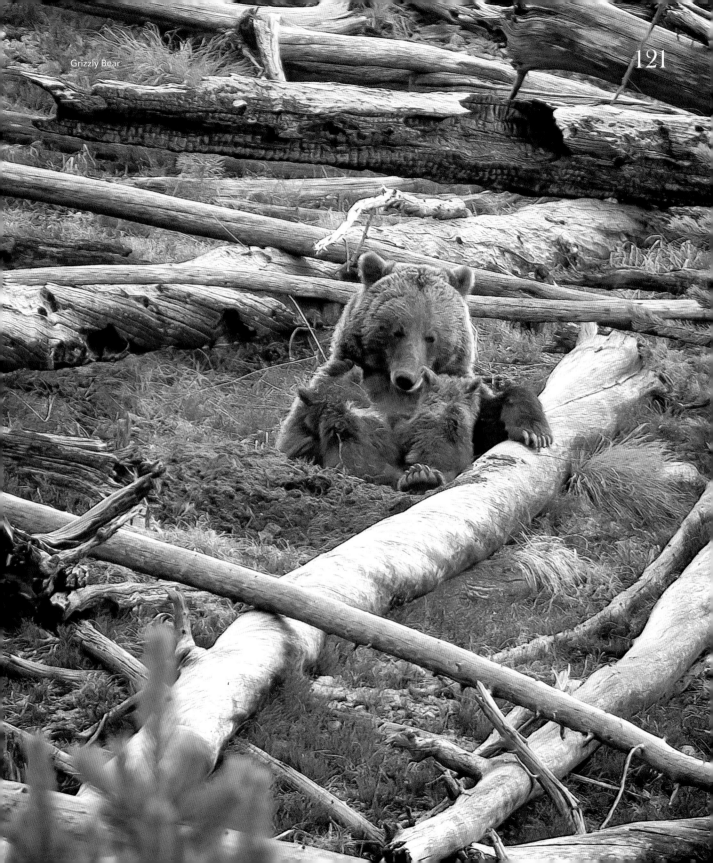

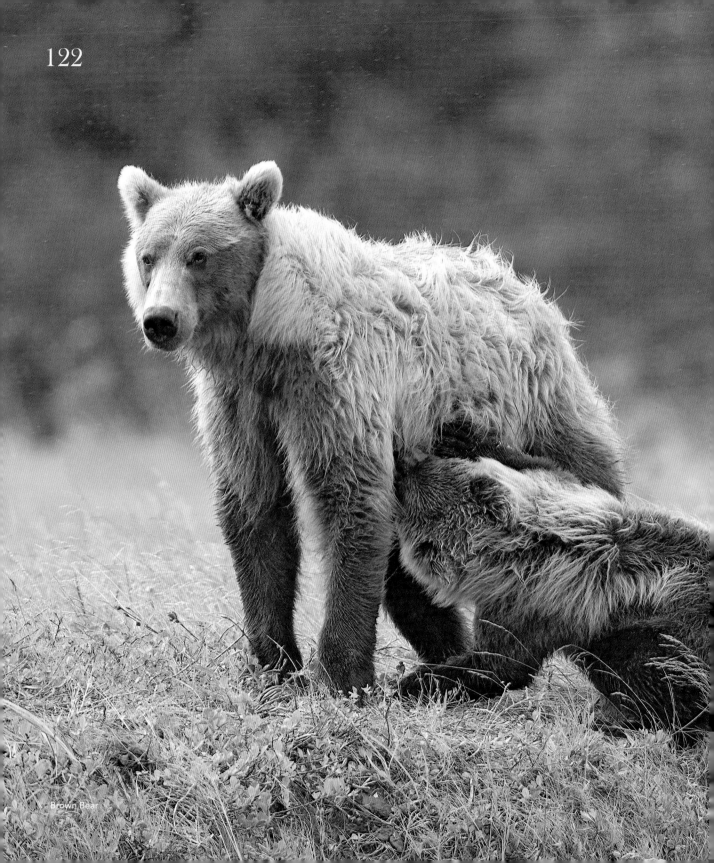

Brown Bear

Nursing Duty

The peak time for a mother bear to nurse is during the cub's first 5 months of life. The younger the cub, the more it needs to feed. Mother bears with very young cubs must stop all other activities regularly to allow their babies to nurse.

Weaning the cubs is a prolonged process, and the rate of nursing slowly decreases over the next 2-4 months. During this time the young are gradually switched to a regular diet, with nursing duty tapering to fewer feedings as the cubs get established on other foods.

Cubs feed on their mother's rich, nourishing milk and grow the most quickly during the first year of life. Black Bear cubs typically nurse for about 7-8 months. Brown Bear and Polar Bear cubs nurse for a much longer period, around 2 years. Brown Bear cubs may nurse occasionally until they're up to nearly 3 years of age, apparently more for comfort than for nutrition.

Litter size

Litter size depends on the species and the overall health of the mother. Black Bears and Brown Bears, including Grizzly Bears, produce a range of one to five young, with an average litter of two cubs. In the eastern United States, a Black Bear litter of three cubs is not uncommon, while litters of four are rare and five are exceptional. Brown Bears along the coast have access to more fish and tend to produce more cubs than inland bears, which have less consistent food sources. Polar Bears have a range of one to three cubs in a litter. Although it's not uncommon for these bears to have a lone cub, only about 10% of Polar Bear litters have three cubs.

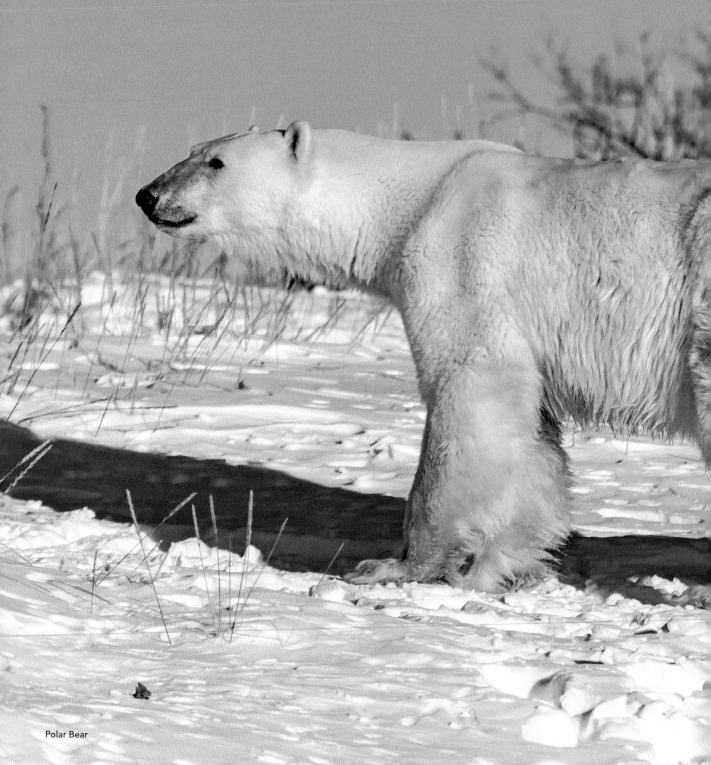

Polar Bear

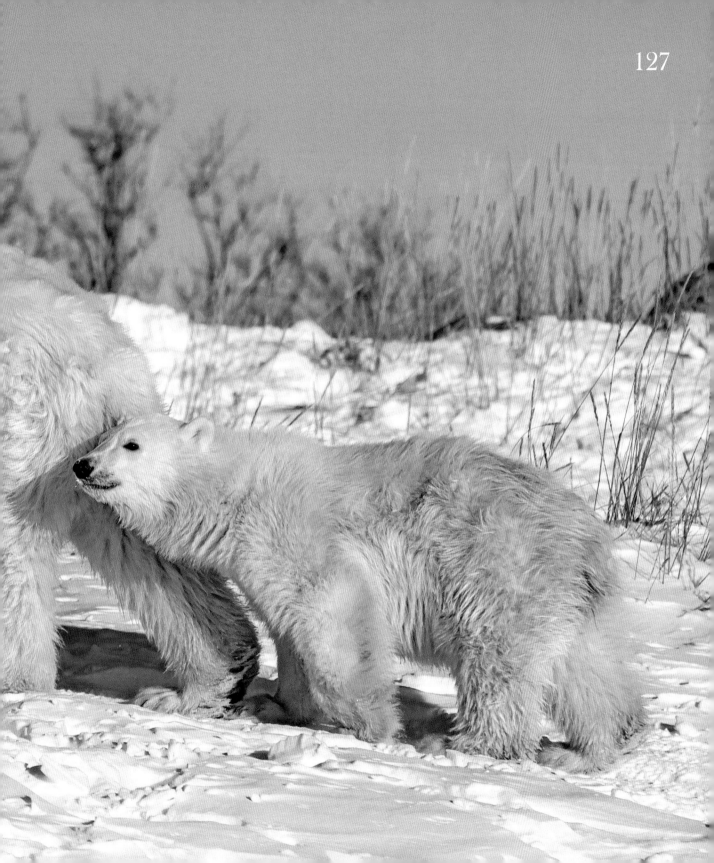

Black Bear

Family planning

The interval of time between litters varies, depending on when a mother disperses the young of her previous litter. In addition, her diet and age, the density of bears in the area, and the amount of human disturbance all play a role in the interval and her fertility. Once a female bear is sexually mature and starts breeding, she usually settles into a regular schedule of giving birth based on the length of time she keeps her cubs. Black Bear cubs remain with their mothers for up to 18 months, so females usually have a litter every other year. Brown Bear cubs and mothers can stay together for up to three years, with mothers giving birth every three years. Intervals for Polar Bears are slightly longer, with litters occurring every three to four years.

A difficult beginning

A challenging part of a cub's life is the first dozen or so months. The mortality rate is lower for the first few months of life and gradually increases until cubs reach 1 year of age. While Black Bear cubs are in the den, their mortality rate is about 25%. Brown Bear cubs are in the 30-40% range, while Polar Bear cub mortality is 20-30%. Compared with the 70% mortality of Gray Wolf pups, you can see that bears do fairly well.

When young cubs are still in the den with their mothers, life is relatively safe but difficult. Cubs are born with only a thin covering of fur, and keeping warm is problematic if they aren't snuggling against their mother. Another concern is the exclusive food—mother's milk. If the milk dries up, it becomes a life-threatening situation for the nursing cubs.

Black Bear

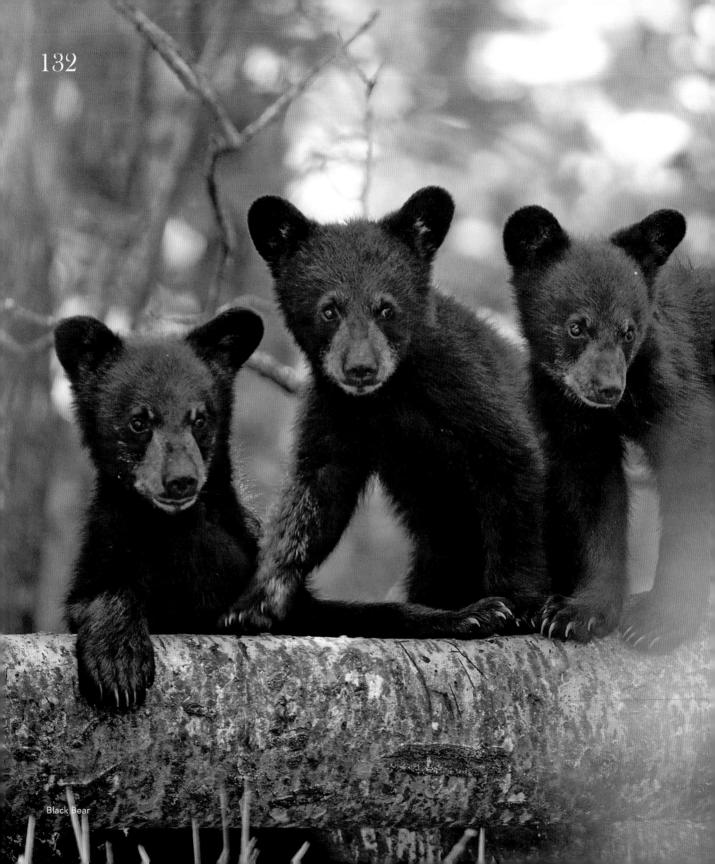

Black Bear

Wolves also play a part in cub mortality in the den. Wolves are known to find the dens of hibernating mother bears, dig out the cubs (and sometimes the mother), and eat them. Wolf packs use this strategy when their main food supply, such as deer, runs low.

When the cubs leave the den, the risk of death increases. One of the biggest threats to a cub is another bear, particularly an adult male. Mothers with yearling cubs avoid boars at all costs because they kill cubs. It may seem strange that male bears kill cubs, but when a mother loses her cubs, she goes back into estrus prematurely and becomes ready to breed. Thus, a boar will kill a cub to provoke the opportunity to mate.

In the first year after leaving the den, the mortality rate rises to around 50%. During the second and third years, the rate drops to 30-40%. Life stabilizes once bears reach adulthood, and they tend to live a normal life span.

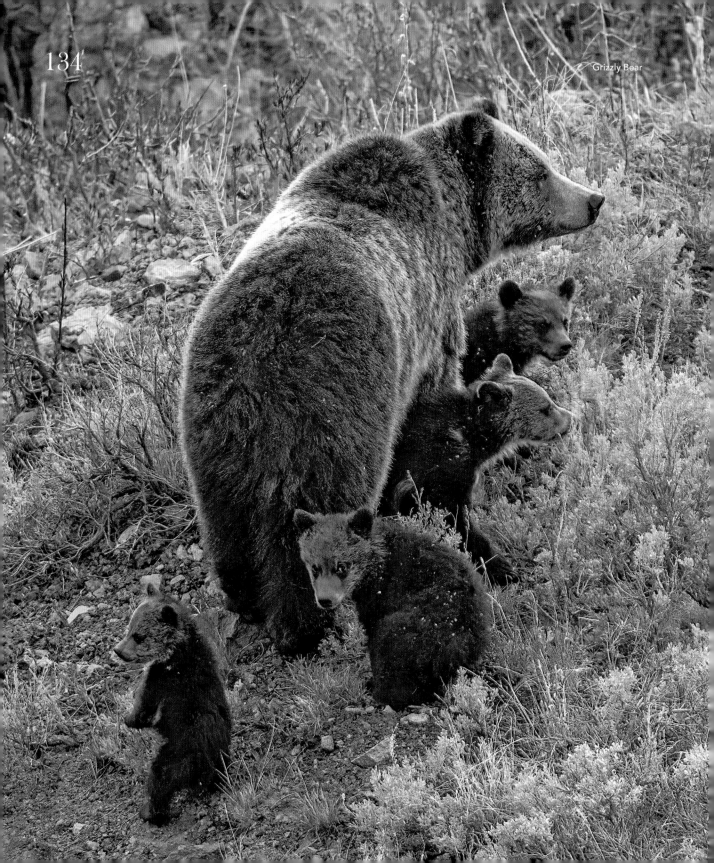

Grizzly Bear

Mixing up cubs

Many wildlife experts report that when mothers meet at major feeding locations, their cubs get mixed up. Some claim that mother bears adopt young cubs, but there is not much scientific evidence to support this idea. If it happens, it's more likely that when two mothers feed and their cubs play, one mother wanders off, leaving the other with additional cubs.

Other accounts state that when two or more mothers mingle at a feeding ground with their cubs, one mother sometimes leaves with another bear's young cubs. This can result in a number of different combinations of mothers and cubs, including mothers left without any cubs.

It is not known how often or why mixing or adoption occurs. Mother bears are either unable to differentiate their cubs from others or they are highly tolerant of strange cubs. In my view, since bears have one of the best olfactory systems in the animal kingdom, the mothers must know their cubs by scent—making tolerance the reason for mixing up cubs.

The miracle of hibernation

Black and Brown Bears are perhaps best known for the fact that they hibernate in winter. Hibernation is not a response to changing weather, extreme cold, or lots of snow, as many people believe—it's a reaction to reduced food supplies. Thus, bears in captivity, which are fed regularly, do not hibernate. Similarly, many bears in the wild won't hibernate when food is abundant during mild winters without snow.

Hibernation in bears is a state of inactivity with a high degree of dormancy. Metabolic rates, heart rate, breathing, and body temperature are greatly reduced at this time but still functioning. During the summer, Polar Bears go into walking hibernation, a state in which their metabolic rate is reduced, but they are still active.

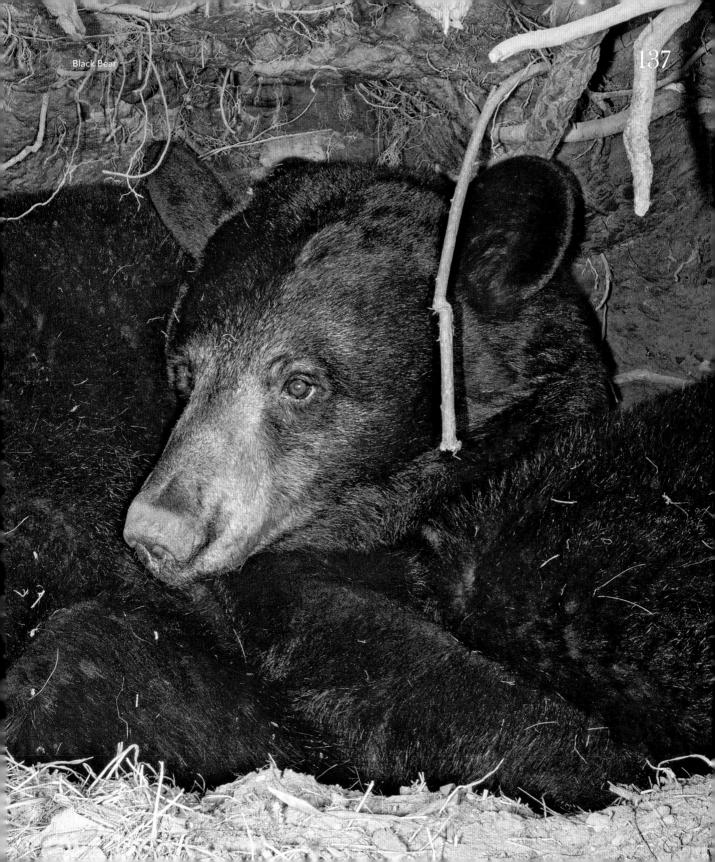

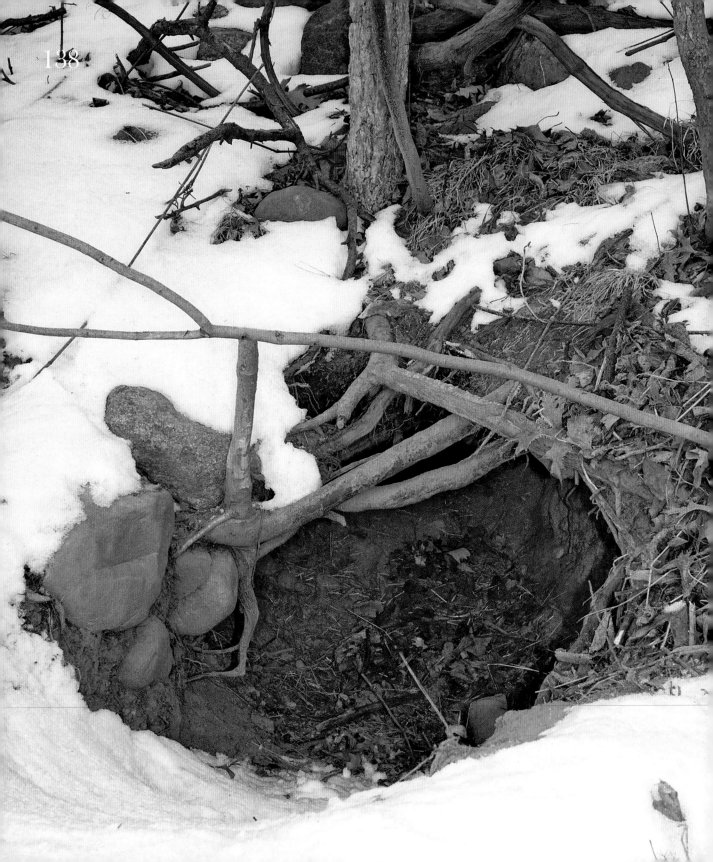

Bear hibernation is different from the deep-sleep hibernation experienced by groundhogs, chipmunks, and other similar animals. It usually takes these critters several weeks to attain their extremely low metabolic rates. It doesn't take bears long to achieve their near dormancy, but they are light sleepers, waking often and moving around the den, sometimes several times a day. Occasionally, during a very warm spell, bears will leave their dens and mill about for a day or more before returning. They may also switch dens in midwinter. When the weather warms, bears need to be awake enough to rescue their cubs and escape the incoming water that often floods the dens in springtime.

The kidneys and other digestive organs slow during hibernation, and metabolism decreases as much as 75%. Heart rate dwindles to only 8-12 beats per minute. Respiration also drops dramatically, to about two breaths per minute. During one winter, I spent some time in a den with a hibernating mother bear. It was easy to count her breaths per minute because the exhalations were audible and steam condensing from her breath was visible in the cold air.

Body temperature also drops a significant 5-10 degrees, falling to a range of 87-93° F. Interestingly, the core temperature of mother Polar Bears during denning is reduced by only one degree, presumably because of the arctic habitat around them. If the body temperature of these bears were to dip much lower, they would risk freezing.

The most incredible aspect of hibernation in Black and Brown Bears is that they do not eat, drink, urinate, or defecate for up to six months. The digestive function stops, and bowel movements stop. Bears occasionally groom themselves and their cubs during winter, resulting in fecal plugs of hair and the slough of foot pads. By springtime, this fecal matter, which is very dry and can be as long as 5-7 inches, is expelled as the bear's first bowel movement.

Under normal conditions, a buildup of urine could poison a bear. Urea, the chief component of urine, is a waste product formed when proteins are broken down during digestion. The cycle of proteins becoming urea is interrupted during hibernation, and urea production is reduced. The small amounts of urea that are created are broken down by the bear's system, preventing the buildup of deadly toxins. This biochemical part of hibernation starts several weeks before the bear actually enters its hibernating den.

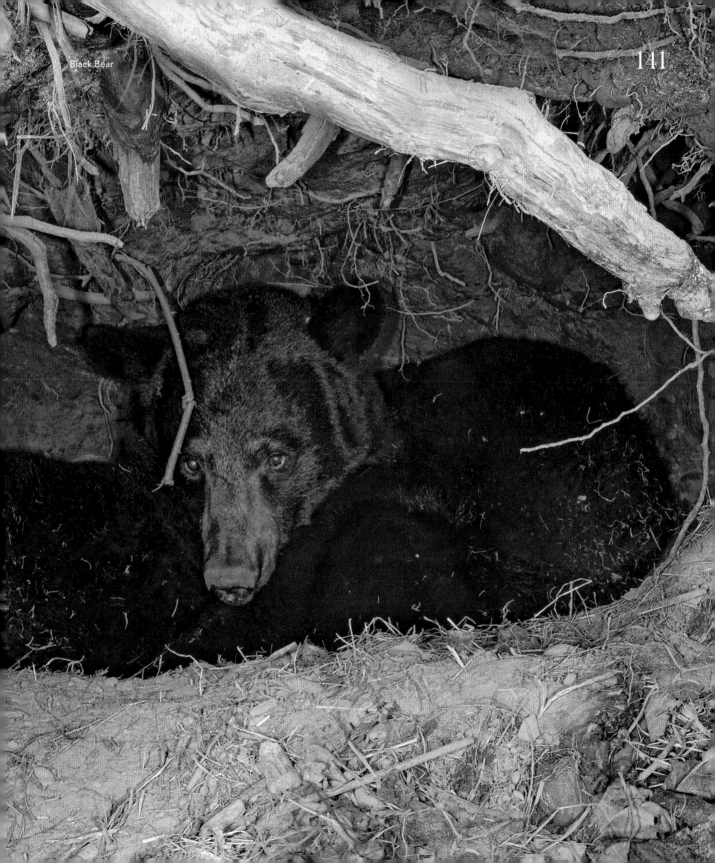

Black Bear

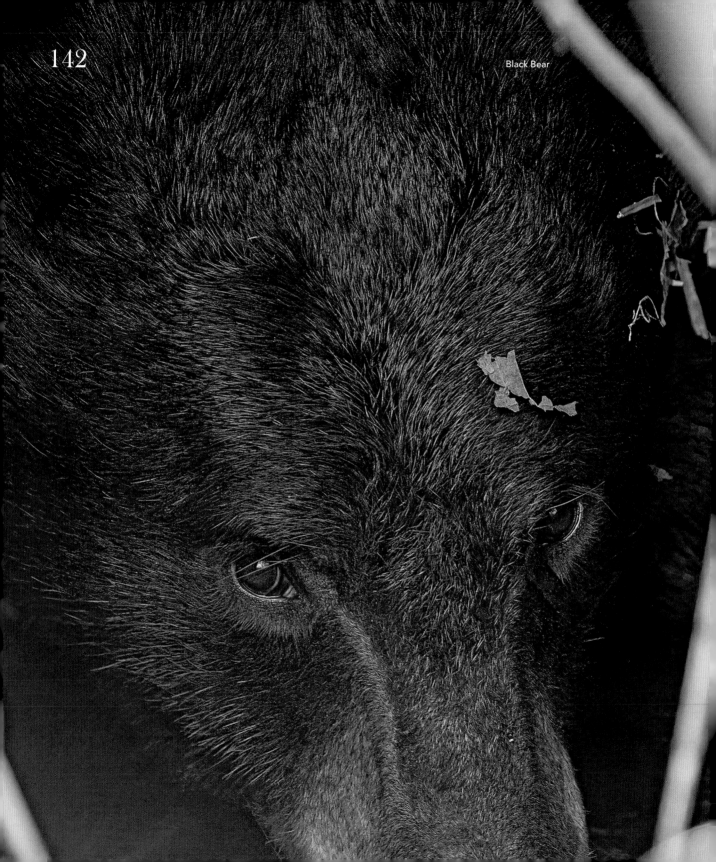

During hibernation, bears have higher levels of fat in their blood than usual and a total cholesterol level that is more than twice as high as the normal level in humans, yet they show no signs of hardening of the arteries or gallstones. If scientists were able to unlock these mysteries, it could help many people who suffer from these maladies.

More amazing is that, even though bears are inactive for many months, they don't experience muscle atrophy. If we were to stay still for that long, our muscles would be so weakened that physical therapy would be necessary just to be able to walk again.

The length of hibernation depends on many factors, including climate, location, age and sex of the bear, reproductive status, and body fat. Bears in northern climates enter hibernation sooner and hibernate longer than southern bears. Northern bears also need more fat to survive their longer winters. In Arizona, southern California, and Florida, bears with a consistent food supply won't hibernate at all.

Den diversity

Dens are as diverse as the bears within them. Den sites vary widely, depending on habitat, elevation, the density of bears in the area, and so much more. Most dens are in secure places away from people.

Usually, a bear den is an excavated hole in the ground or a natural cave or cavity. Some bears will den in hollow tree trunks. Others den under large rocks, fallen trees, at the base of upturned trees, in culverts or brush piles, beneath summer cabins or homes, and even underneath vehicles. Still others lie on a nest of plants and hibernate out in the open, using snow as a covering for the winter.

There seems to be no end to the places a bear might select when it comes to hibernating. One resourceful Black Bear near the Minnesota–Wisconsin border spent the winter in a Bald Eagle's nest, approximately 70 feet up a tree! Polar Bear mothers are more predictable. They almost always dig themselves snugly into a snowbank.

Some bears use the same den year after year. Others move around, constructing a new den each season. The entrance hole is typically a few feet from a small chamber, which is often not much larger than the occupant. Bedding normally consists of grasses, leaves, and evergreen needles.

Over 60% of all Grizzly Bears den in the mountains on north-facing slopes. Many Grizzly dens have a long shaft leading to the chamber. Nearly all Polar Bear dens are on land, within 5 miles of the coast. Almost half of all Polar Bear dens used by mothers to give birth face south, and most of these are dug into snow. Some go deeper, with chambers excavated in the frozen ground. Most of these chambers are at the end of a long (10-foot) tunnel.

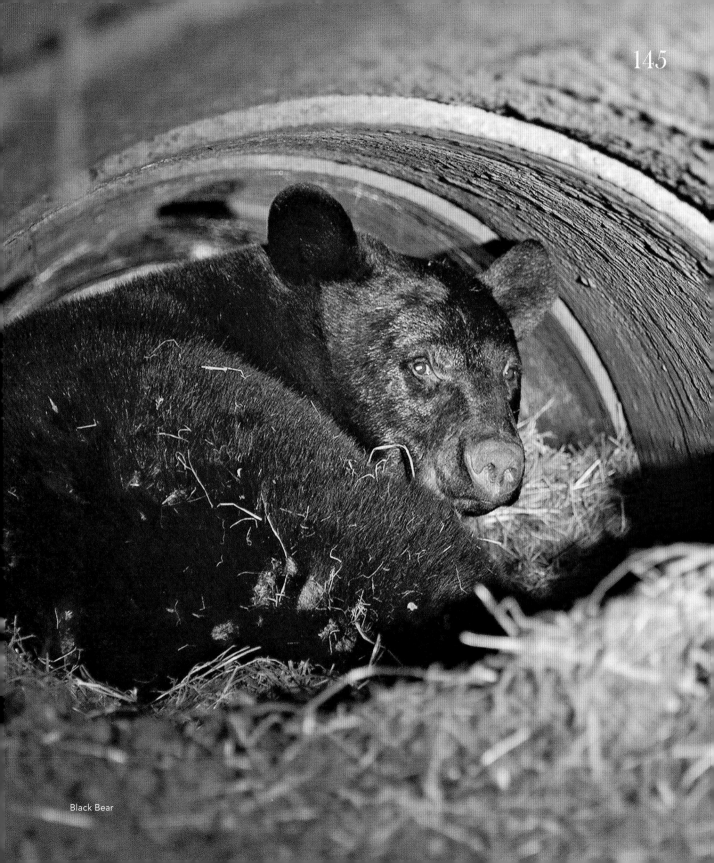

Black Bear

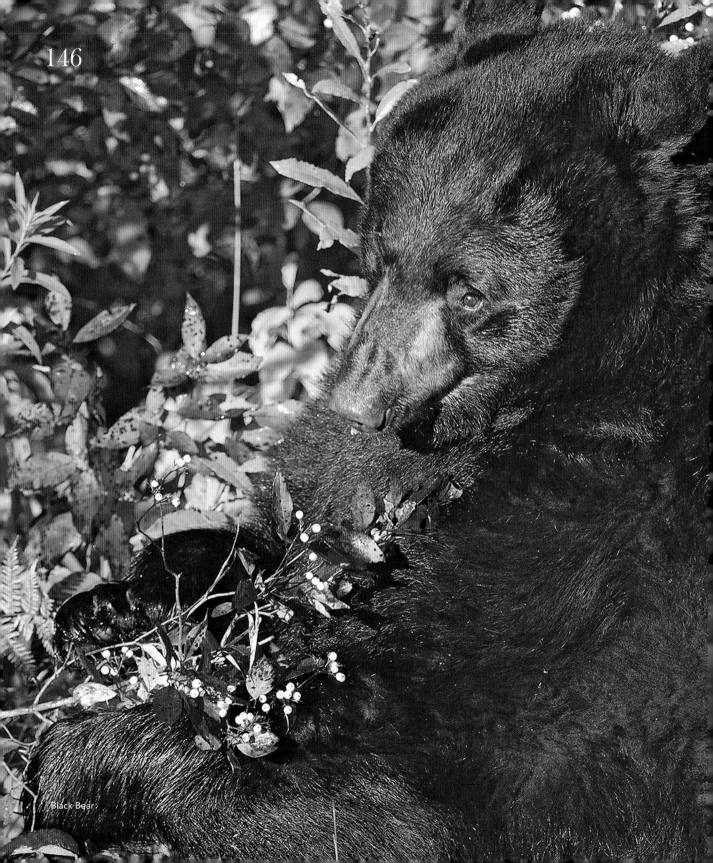

Black Bear

Preparing for winter

It is extremely important for bears to prepare for hibernation. If they don't build up enough fat to last the entire winter, they won't survive. Bears prep for hibernation by eating huge quantities of food during late summer and early fall. They can eat for 20–22 hours a day, resting only now and then between bites. This massive increase in appetite is called hyperphagia.

Average-size Black Bears normally consume 6,000–8,000 calories per day. During hyperphagia, the intake jumps to an astounding 20,000–40,000 calories per day. In humans, consuming that many calories would mean having to eat 70–100 cheeseburgers every day! With the increased calories, Brown Bears can gain up to 400 pounds, and pregnant bears may double their summer weight. The extra poundage is vital because hibernating bears can lose up to 40% of their weight during winter, despite burning only 4,000 calories per day. Polar Bears can eat up to 100 pounds of seal meat and fat at one sitting.

Black Bears add a fat layer of up to 4 inches during hyperphagia. Brown Bears add up to 2–4 pounds each day, resulting in a fat layer measuring 6–8 inches. Polar Bears put on the thinnest layer of fat, closer to 2 inches.

At the end of summer, Black and Brown Bears consume mostly berries and other fruit, along with acorns and other nuts. Many green plants and an occasional meat meal supplement the diet. In addition to eating mass quantities, bears also need to drink large amounts of water. The extra water helps build fat cells and also acts as a water reserve during hibernation.

Bears stop eating shortly before entering the winter den. Triggers for this event are a sharp decrease in available food and an increase in energy output to keep warm. More than likely, the change in the length of daylight, called the photoperiod, and other factors also play into the triggers that send bears into their dens.

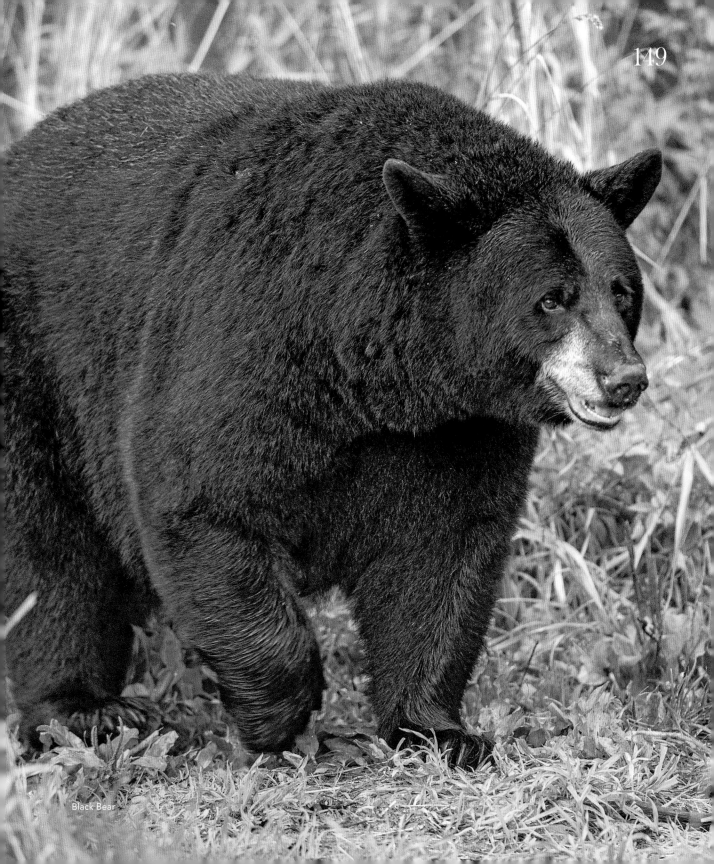

Black Bear

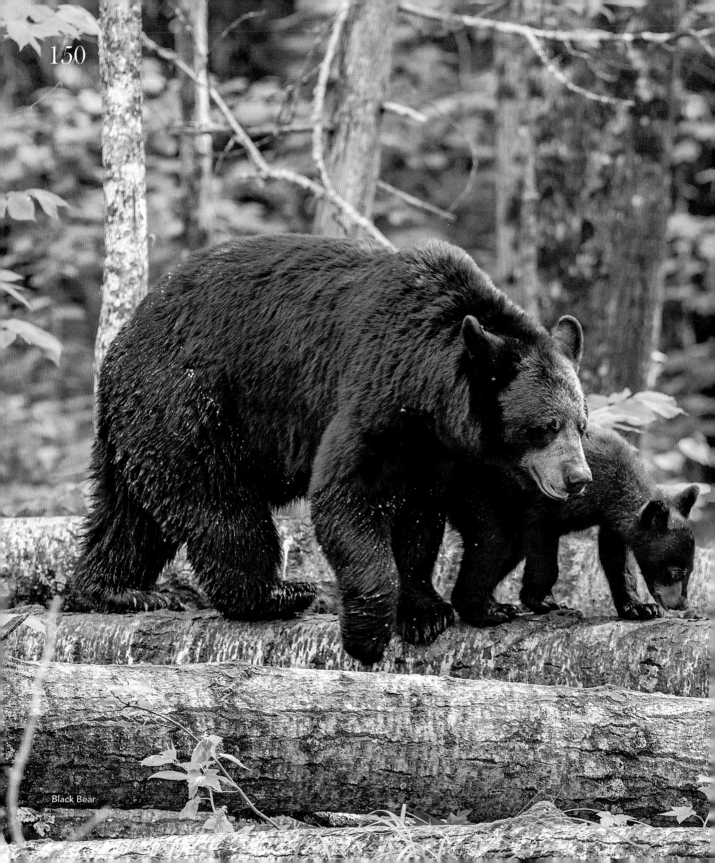

Black Bear

Emerging in spring

Emerging from the den in spring is usually a slow, deliberate process. Males come out first, followed by mothers with cubs. Young that are 3–4 years old emerge last.

Bears tend to be a bit sleepy and lethargic for several days before returning to their normal spring and summer speed. Often there is still snow on the ground, but the sun is usually high enough to provide warmth and melt the snow. A bear's physical condition in spring is linked to its health and physique when entering hibernation. Some bears come out emaciated and looking terrible, but most appear to be in good shape.

Usually, bears are more interested in water at first than food. After satisfying themselves with water, they start eating high-protein foods. They will consume many plants, which help clear the kidneys and digestive system, and also winterkill, which provides the complete protein found in meat.

Cautionary measures

Many people mistakenly believe that a mother Black Bear is more of a danger than other bears, including Grizzlies. While all bears can be very dangerous, especially mothers with cubs, Grizzly Bears are the most unpredictable and deadly, even more so than Polar Bears, which are known to hunt and kill humans. What makes Grizzlies so dangerous is their volatile nature. At times they seem to just snap and become mortally aggressive.

Black Bears live in forested regions and have a survival strategy of climbing trees to escape peril. Much of their early life is spent up in a tree. Grizzly Bears are open-country bears with no place to hide. A Grizzly's strategy for staying alive is to quickly attack and neutralize any perceived threat. Grizzlies are so well known for this behavior that they should be avoided at all times.

It is important to remember that bears are animals that, in order to survive, kill and eat other mammals, including humans. Fortunately, bear attacks on people are extremely rare. It's much more likely for a car crash to occur while driving to the wilderness than it is to see a bear in the backwoods, let alone to be attacked by a bear. If you are knowledgeable about bears and take reasonable precautions when traveling in bear country, you will likely not have a problem with them.

Polar Bear

Respecting bears

Bears are some of my most favorite animals on the planet. Whether it's Black Bear cubs play fighting in Minnesota, Brown Bears fishing along the Alaskan coast, or powerful Polar Bears swimming in the Arctic, observing and photographing these magnificent creatures is always exhilarating for me. Over the years I have tried to capture images that reflect the lives and natural history of bears, and in so doing, I have come to love and respect them all the more. In my mind and heart, the fact remains—bears rule!

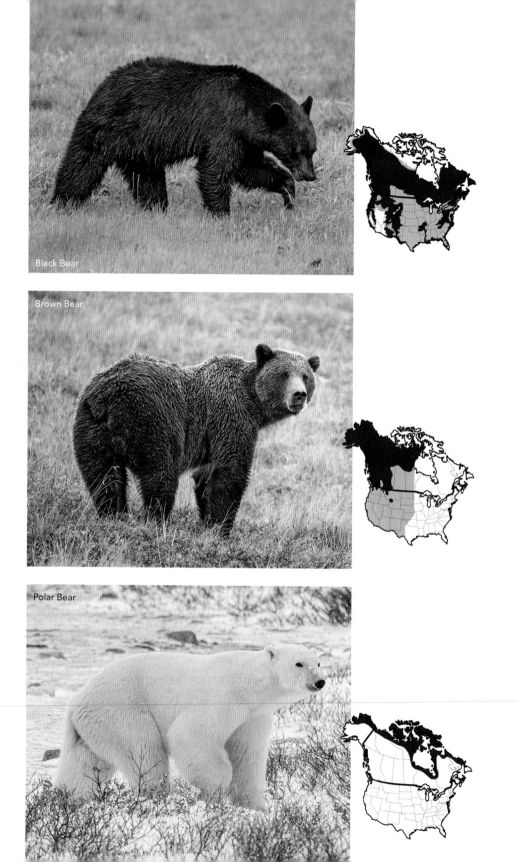

Black Bear

Brown Bear

Polar Bear

Featured bears

This photo spread shows all three bear species in the United States and Canada and their ranges. Ranges shown in dark red indicate where you are most likely to see the animals during the year. Former ranges are shown in tan. Like other wildlife, bears move around freely and can be seen at different times of the year both inside and outside their ranges. Maps do not indicate the number of individuals in a given area (density).

Where to spot bears in the wild

Spotting a bear in the wild is an incredible experience, but bears are often secretive, quiet animals, so to spot one, it's often best to head to wilder spots known for their bear populations. Here's a list of locations known for Black Bears, Brown Bears, and Polar Bears, respectively.

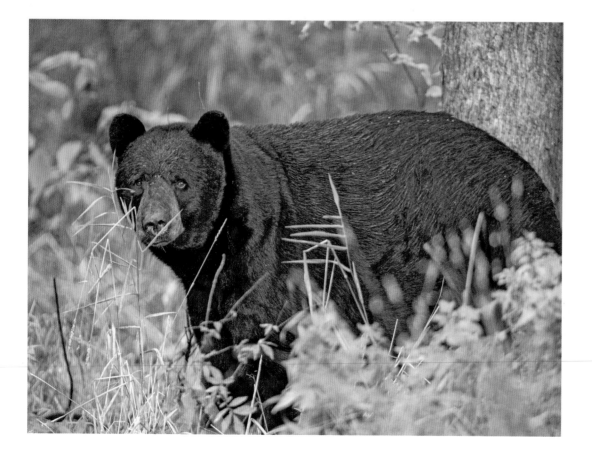

Black Bears

**American Bear Association,
Vince Shute Sanctuary**
Orr, Minnesota
www.americanbear.org

Glacier National Park
Montana
www.nps.gov/glac

Great Smoky Mountains National Park
Tennessee and North Carolina
www.nps.gov/grsm

North American Bear Center
Ely, Minnesota
bear.org

Shenandoah National Park
Virginia
www.nps.gov/shen

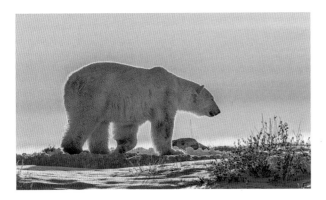

Brown Bears

Grand Teton National Park
Wyoming
www.nps.gov/grte

Grizzly & Wolf Discovery Center
West Yellowstone, Montana
www.grizzlydiscoveryctr.org

Lake Clark National Park & Preserve
Alaska
www.nps.gov/lacl

Katmai National Park & Preserve
Alaska
www.nps.gov/katm

Kodiak National Wildlife Refuge
Kodiak Island, Alaska
www.fws.gov/refuge/kodiak

Yellowstone National Park
Wyoming, Montana, and Idaho
www.nps.gov/yell

Polar Bears

Churchill, Manitoba
www.travelmanitoba.com/churchill

About the author

Naturalist, wildlife photographer, and writer Stan Tekiela is the originator of the popular Wildlife Appreciation series that includes *Loons; Owls;* and *Wolves, Coyotes & Foxes.* Stan has authored more than 190 educational books, including field guides, quick guides, nature books, children's books, and more, presenting many species of animals and plants.

With a Bachelor of Science degree in natural history from the University of Minnesota and as an active professional naturalist for more than 35 years, Stan studies and photographs wildlife throughout the United States and Canada. He has received national and regional awards for his books and photographs and is also a well-known columnist and radio personality. His syndicated column appears in more than 25 newspapers, and his wildlife programs are broadcast on a number of Midwest radio stations. You can follow Stan on Facebook, Instagram, and Twitter, or contact him via his website, naturesmart.com.